making your dreams come true

making your dreams

Young British Photography

come

Edited by Jone Elissa Scherf and George St. Andrews

true

Hatje Cantz

FOREWORD

Motoring has always been associated with dreams — dreams of freedom, speed, excitement, glamour. The goal of BMW Financial Services Group GB is to enable its customers to realise their dreams. In commissioning six outstanding young British photographers to interpret the theme "Making your dreams come true" for their Millennium project, BMW Financial Services Group GB wished to support the creation of stimulating new work in a medium increasingly important in contemporary art. The six artists in question, Tom Hunter, Sarah Jones, Sophy Rickett, David Shrigley, Bridget Smith and Hannah Starkey were given a free hand to interpret the commission as they saw fit, and they have produced work of originality, w t and a strange beauty. I would like to thank them and all those involved in this project, which sets a benchmark for bold and imaginative collaborations between artists and sponsors. We are very happy that twelve of the photographs have been selected to join the UK's National Collection of the Art of Photography at the Victoria and Albert Museum, London.

GÜNTER LORENZ
Member of the Board of Management
BMW Group

INTRODUCTION

THIS BOOK PRESENTS SIX YOUNG BRITISH ARTISTS working in the medium of photography: Tom Hunter, Sarah Jones, Sophy Rickett, David Shrigley, Bridget Smith, and Hannah Starkey. All six took part in the "Making your dreams come true"[1] project in 1999, and all have contributed to the contemporary 'edge' that has made British art such a lively force in recent years.[2] They use cameras, among other media, but they photograph as post-moderns. That is to say, these artists do not photograph to describe and therefore explain. Instead, they use the astonishing descriptive power of photography to pose questions. They surprise us by using the camera to photograph aspirations and ideas, fictions and dreams. They rely on us to bring our own imaginations to the pictures. If we do, we will certainly be rewarded.[3]

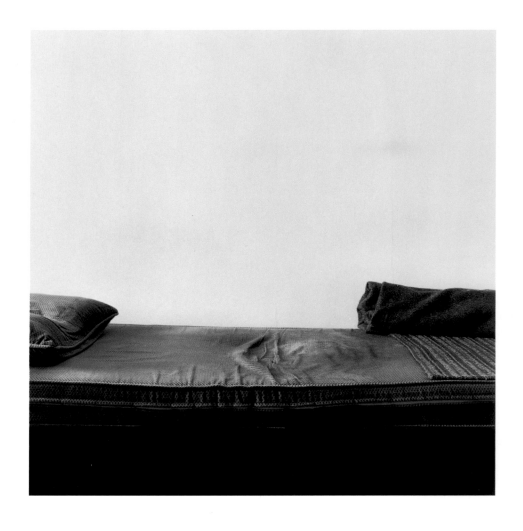

SARAH JONES CONSULTING ROOM (COUCH) (XV) 1997

SARAH JONES graduated from the Goldsmiths College MA course in 1996. She had already come to the notice of critics and collectors with a series titled *The Consulting Room*, first exhibited in England and France in 1995 (fig. p. 6).[4] These photographs present details of the couches familiar from the consulting rooms of psychoanalysts. In fact, they were taken in the Royal Institute of Psychiatry in London. The mundane particularities of the couches—the colours, textures and precise state of dishevelment of pillows, blankets and plastic sheets—were recorded with a view camera. Many things are stated as brute facts, but much more is implied by association. The space beneath each couch is as dark as any lost psychic life or irrecoverable memory. The walls behind belong to the institutional space in which the private and the public meet. The large space above the couch is filled with the ghosts of fraught disclosure, but the space we are shown is arbitrarily cropped, suggesting the confinement of a cubicle. Sarah Jones is currently photographing consulting rooms in New York.

The works illustrated here (plates pp. 23–29) belong to a series first shown in 1997 and continued afterwards. The series, broadly titled *The Dining Room*, involved girls in their early teens—friends in an English village. The initial photographs posed the girls in the well-appointed dining rooms of their homes. They were presented, without their parents, formally arranged, as if awaiting the next guest. (You could say that the couches of the early series became tables, and that an unseen dialogue became an invisible conversation.) Later the series widened to include other rooms and the garden. The psychological dynamic of these contemporary tableaux resides in many features: in the way young girls interact with each other, with different aspects of their suddenly growing adolescent selves, with the prescribed spaces and messages derived from the parental habitat, and with the possibilities of the semi-natural state of the garden and the environment beyond. As with *The Consulting Room*, *The Dining Room* (and its later variations) brims with the traces of voices, glances and uncompleted narratives. Some of this buzz of discourse can be related to the rich psychological spaces opened by Cindy Sherman, but Sarah Jones has her own wide frame of reference. It includes, for example, the mid-Victorian modern, Clementina, Lady Hawarden, whose photographs of her adolescent daughters, around 1860, have been carefully studied by Sarah Jones.[5] Both artists give us the space as viewers to conjure possible realities—including, of course, our own, from a number of subtle cues. As Sarah Jones herself has remarked: "These images, set against an urban backdrop, deal with what it is to remember or to begin to realise what we desire or once desired."

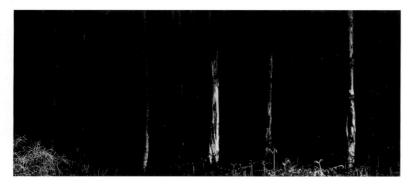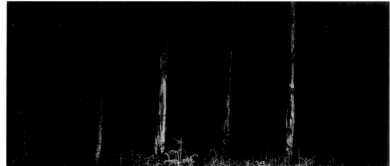

SOPHY RICKETT PINE TREES (LAKE DISTRICT) 2000

SOPHY RICKETT also created an early series of work which might influence the way we see the works in this exhibition. *Pissing Women* (1995), photographed in black and white, showed well-dressed young women raising their skirts to urinate, in masculine posture, in various well-known central London locations. The scenes were a humorous feminist skit on typical behaviour by laddish men. Some elements from the series continued into the works made by Rickett during and after taking her MA at the Royal College of Art. Night, the city, artificial light, danger and the notion of habitual, unconscious, constraints are all features of her later work. The black night skies in the pieces exhibited here recall the darkness beneath the couches photographed by Sarah Jones. These are spaces for reverie. In fact, they are indeterminate spaces, apparently located in the nowhere landscapes to be found on the arterial roads of outer London. A narrow band of untended nature is lit—with a kind of unnatural sunshine—in this terrain of motorways, slip-roads, traffic islands and roundabouts. Isolated figures, sleeping or sitting, animate the space and draw our voyeuristic gaze towards their unknowable dreams or thoughts. Sophy Rickett has spoken of the figures in these landscapes and asked: "Are they paralysed by their very presence in this hinterland that offers no way of escape, or are they contemplating the dark space of the night, the secrets it hides and the incredible possibilities that it contains?" She has subsequently worked in Scotland (a poplar plantation near Dundee), the English Lake District (Grizedale Forest) and in the most spectacular landscape of hyperreality or supermodernity, Los Angeles. These places have become rather similar in Rickett's photographs and she has observed that "Finding a great location is like stumbling across an old memory, recognising something I did not know I had forgotten. I think it is more likely that my work is influenced by a state of mind than by where I happen to be staying. States of mind are a lot more difficult to fix than geographical location."[6]

HANNAH STARKEY is the third of our artists to have taken an MA, and the second to attend London's Royal College of Art. She made her breakthrough with works very different from the ones created for the BMW commission. She could be thought of as a new, 21ˢᵗ century, reprise of the "peintre de la vie moderne" imagined by Baudelaire and embodied by Manet. Like Manet, she represents contemporary life—states of feeling and being not hitherto recognised as the material of art. As with Manet, too, Hannah Starkey makes use of mirrors in her representations. A tableau from 1999, *Untitled—March 1999,* uses the mirrors in a female cloakroom or toilet to set up a vista of psychological possibilities, ambiguities and confusion. As with the tableaux of Sarah Jones, Hannah Starkey makes pictures in which action is suspended—or reduced to the flick of a lighter—and narratives are glimpsed rather than engaged. Her scenarios are played out by professional actors and located in characteristic venues of the urban present: a video shop, a student common room, a bar, a café, a bus, a weight-watchers' club, wasteground. The series she made for BMW is another contemporary location: the windows of a betting shop, filled with graphics. She used digital photography to make a narrative. She sets the horses racing but there is a twist: "Our bet is on the yellow horse and therefore she represents part of our aspirations. Ultimately, she is the first to pass the finishing post. But as she is jockeyless, the bet is void."

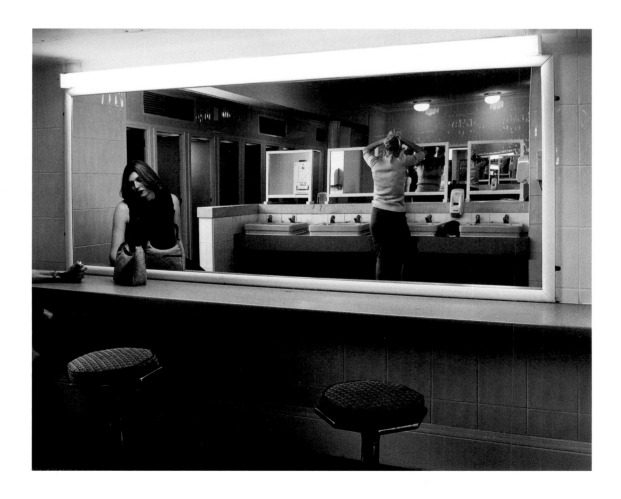

BRIDGET SMITH, the fourth woman in this selection of young British artists, also took an MA at Goldsmiths College. There are also connections with Manet. Her earliest series, of the luxuriously curtained proscenium arches of old-fashioned cinemas (1994), embraced Manet's world of public spectacle. The swagged and gorgeously-shining curtains remain closed in Smith's large, colour-saturated prints, but viewers provide their own assorted narratives. Smith's attention shifted to the 'Glamour' studios assembled by photographers in provincial towns, which catered for portraiture of different kinds. The sitter could choose to be portrayed in personae ranging from the sports jock to the pampered starlet, with many other variations. No one poses in these empty spaces, so what we are left with is the somewhat home-made mechanics of fantasy. Smith has recently been working in Tokyo, photographing the strangely withdrawn nature of urban space and signing, but a more persistent location for her as a photographer is Las Vegas. Her campaigns there have produced remarkable photographs of the boldest or most barefaced illusions available on the planet. The need for and love of illusion is shown to be a profound human trait, as well as an enduring theme for high comedy.

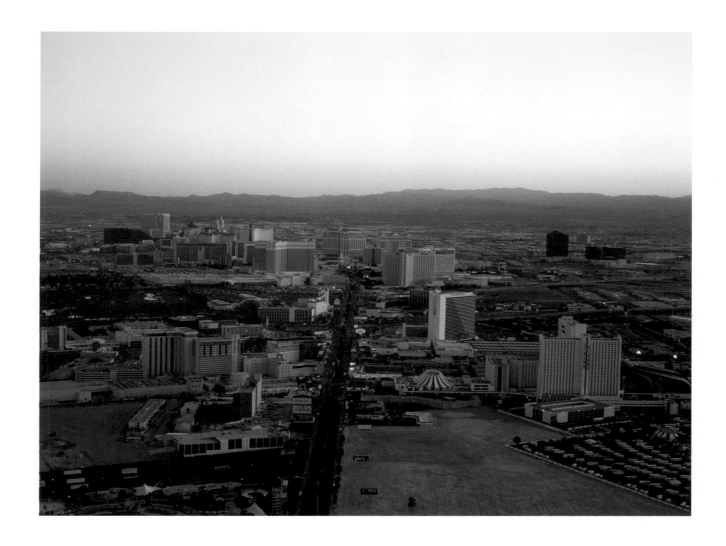

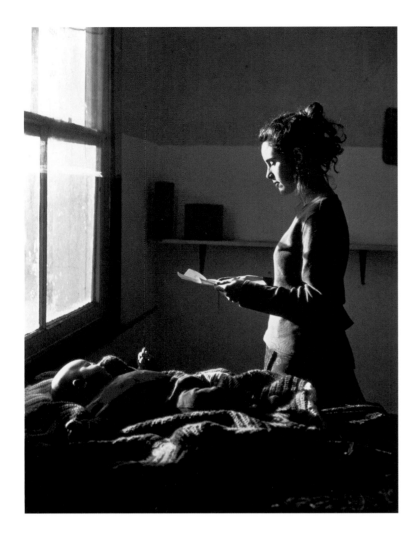

TOM HUNTER WOMAN READING A POSSESSION ORDER 1997

TOM HUNTER also graduated as an MA from the Royal College of Art. Like Sophy Rickett, he had already begun to make a reputation while still at the London College of Printing. For his degree show there, Hunter exhibited *Ghetto* (1994). This was a large three-dimensional model of houses in Hackney, in the East End of London. This area, lived in by many artists and squatters, was given its title from an article in the local newspaper, which described it as "a crime-ridden, derelict Ghetto".[7] Viewers of Hunter's installation could look into the windows of the terraced model houses and see back-lit colour transparencies of the interiors. The model took a year to build and photograph. It is now a well-loved permanent exhibit in the Museum of London and a key element in the exhibition *Creative Quarters* at that Museum (2001). Hunter transformed a so-called "ghetto" into a compelling image of a vital, creative community. His final show as a student at the Royal College of Art was a series called *Persons Unknown*, which was to become very widely exhibited, published and collected. The series portrayed fellow-squatters in Hackney.

Hunter photographed his neighbours with a 5 x 4 inch view camera in the style of compositions by Vermeer. He gave value to people often regarded as antisocial parasites. The crucial photograph in the series is *Woman reading a Possession Order* (pl. p. 11), based on Vermeer's *Girl reading a letter at an open window*. The carefully-lit image follows the composition of the painting, except that the bowl of fruit has become a baby and the window is closed. A *Possession Order*—demanding that squatters leave a building by a stated date—is issued by the local authorities to *Persons Unknown*. Hunter has travelled a good deal, including a year wandering through Europe in a double-decker British bus with a sound system. His pictures of travellers— especially those who move from country to country with the sound-systems for raves—are also pointed assertions of value where it is often not bestowed. He has written of these pictures: "Although my subjects are not from wealthy families, and do not own large estates, they are still proud of, and part of, the landscapes they inhabit… These images show my subjects living out the dreams of the old social elite."

DAVID SHRIGLEY is a suitable artist with whom to end this introduction. Like Tom Hunter, he is—sometimes—a maker of installations and objects. The newly-opened Wellcome Wing in London's National Museum of Science and Industry includes several pieces by Shrigley. One of these improbable objects is a silver trophy offered for achievement in an unusual field of prowess: swearing. He is a distinguished photographer, draughtsman, sculptor and writer. He is a graduate of the Glasgow School of Art. However, he did not study in the highly regarded Fine Art Department there, but—instead—in Environmental Sculpture. He moves from medium to medium and context to context but his sensibility remains consistently humorous, questioning and inventive. Like his colleagues in this exhibition, he wonders aloud and frames his sense of possibility in photographic form: "In the work *Carrots* there is a dichotomy between growing carrots, which is boring, and growing cacti, which are inedible. *Your Name Here* depicts another strange scenario. A snail is selling advertising space on his shell. But what would you advertise there? Gardening products, maybe?"

MARK HAWORTH-BOOTH is curator at the Department of Photography at the Victoria and Albert Museum, London.

1. The 24 photographs illustrated (pp. 15–59) form part of the collection of BMW Financial Services Group UK. They were commissioned in 1999 on the theme "Making your dreams come true".

2. 12 of these works are now in the National Collection of the Art of Photography in the Victoria and Albert Museum, London.

3. The illustrations accompanying the text were not made as part of the BMW commission.

4. Works from this series by Sarah Jones were bought, amongst others, by the private collector Charles Saatchi whose galleries and exhibitions have played a significant, if not uncontroversial, part in the promotion of experimental visual art in recent years.

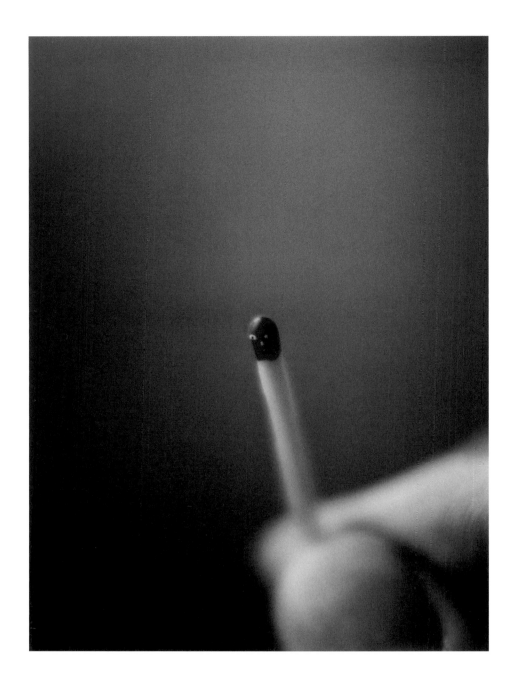

DAVID SHRIGLEY UNTITLED (ARSON) 2000

5. The directors of the Huis Marseille in Amsterdam are to
 be congratulated for showing works by Sarah Jones and
 Clementina, Lady Hawarden, in the same exhibition.

6. "Kate Bush in Conversation with Sophy Rickett", in:
 Sophy Rickett Photographs exh. cat. Emily Tsingou
 Gallery, London 2001.

7. "Tom Hunter", interview with Jean Wainwright, in:
 Hot Shoe International, September/October 1999,
 pp. 18–22.

Tom Hunter

"ALTHOUGH MY SUBJECTS are not from wealthy families, and do not own large estates, they are still proud of, and part of, the landscapes they inhabit… These images show my subjects living out the dreams of the old social elite."

TOM HUNTER

TOM HUNTER

UNTITLED 1999

TOM HUNTER

UNTITLED 1999

Sarah Jones

"ADULTS AND CHILDREN linger in urban gardens and
homes, suspended in private thought. We are left to speculate
what they might want for themselves or others and to picture
the moment they might be projecting or reenacting."

SARAH JONES

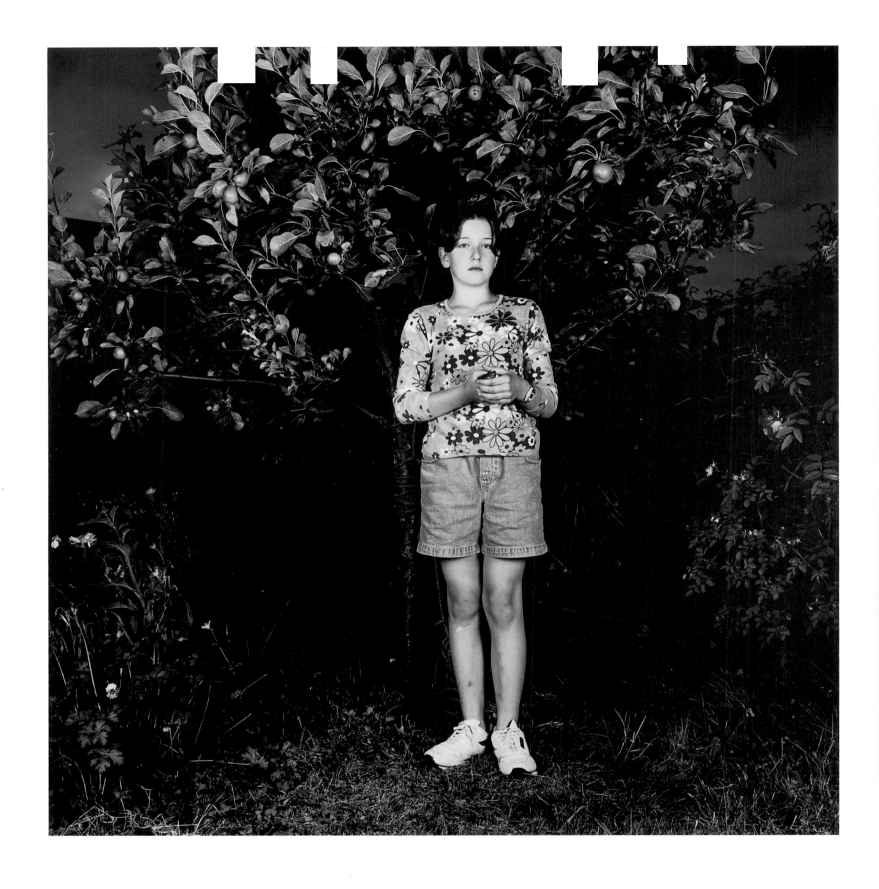

APPLE TREE (CHARLTON) II 1999

SARAH JONES

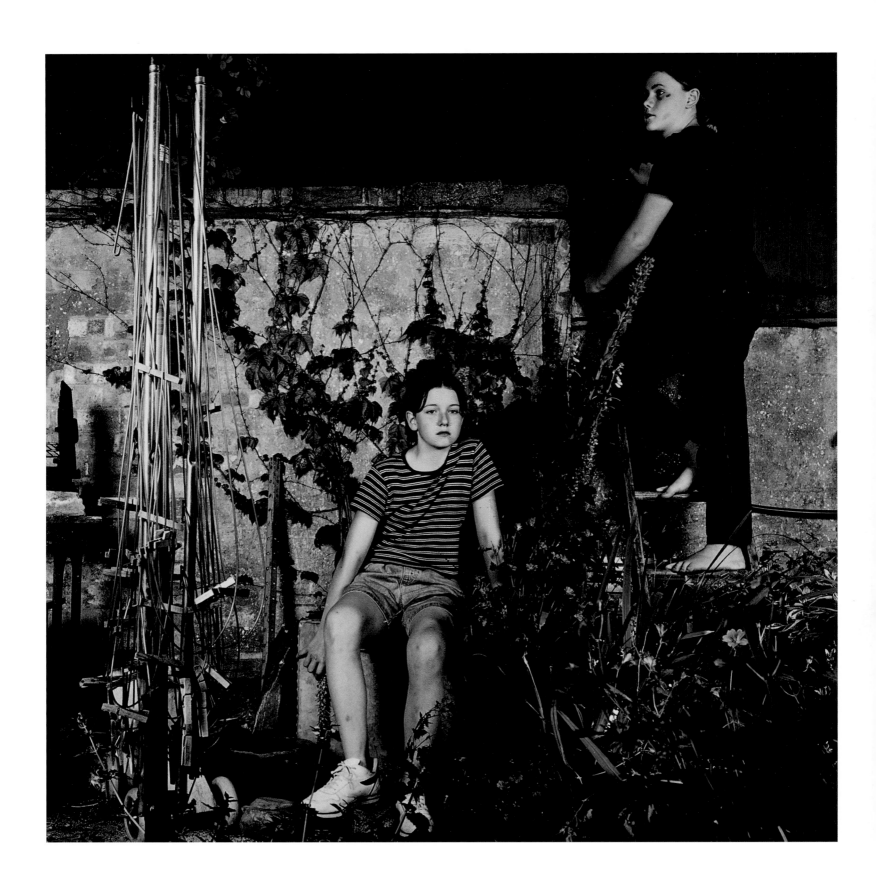

THE WALL (CHARLTON) III 1999

SARAH JONES

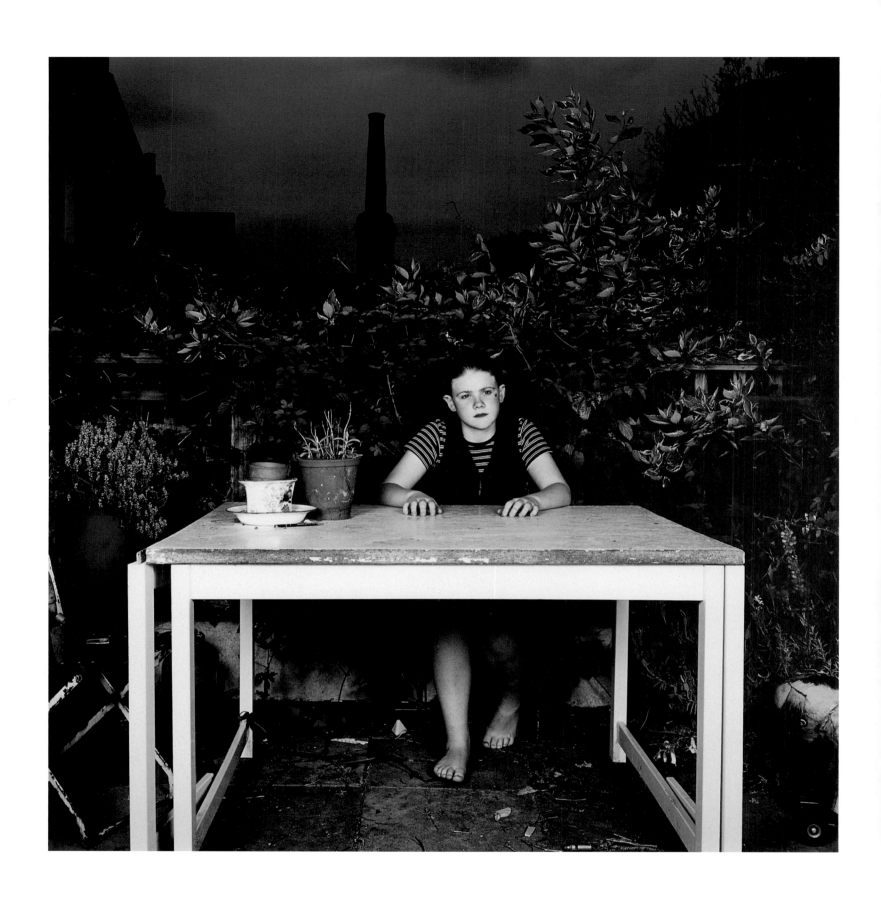

BACK GARDEN (CHARLTON) IV 1999

Sophy Rickett

"THE SERIES TAKES PLACE at night, on the grassy island of a major arterial roundabout — a space that functions as the background to a journey, a gap between two points. The illumination comes from the incidental spill of light from a streetlamp nearby, which foregrounds a space of brightly illuminated grass that gives way abruptly to a deep black sky at the line of the horizon.

The presence of the figures is complicated, ambiguous; they seem settled, as if they have been there for some time, and that the space has come to require them in some way. Have they abandoned themselves to the impossibility of their situation, paralysed by their presence in the road-locked island that offers little chance of (physical) escape, or are they contemplating the dark space of the night: the secrets it hides and the possibilities it contains?"

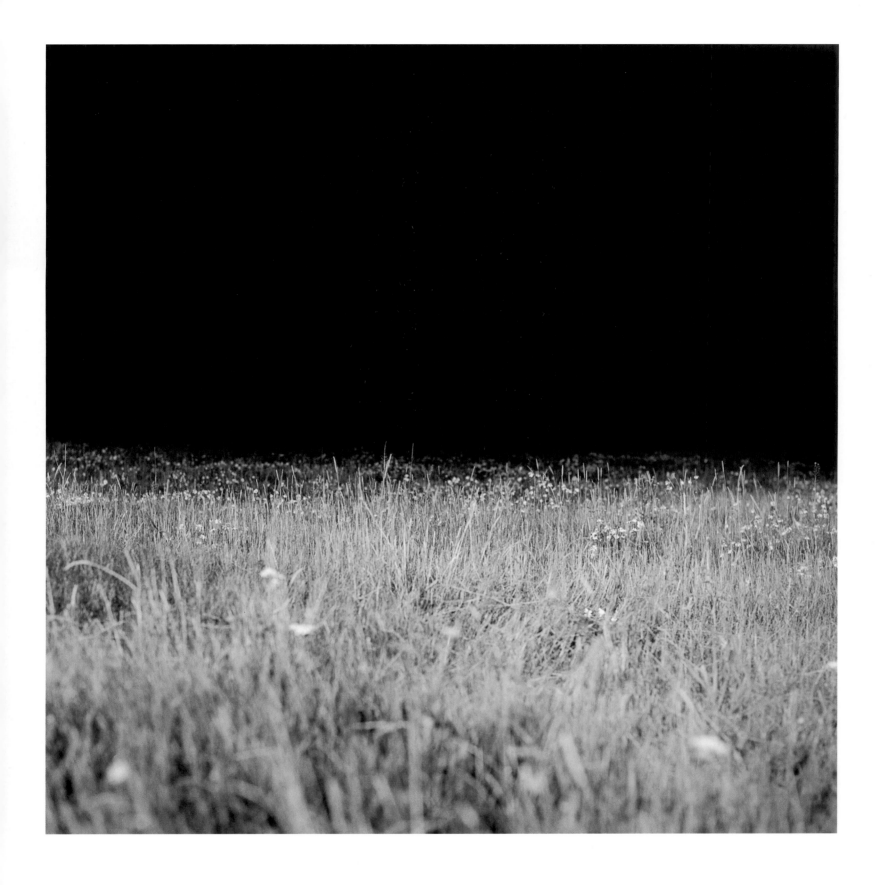

SOPHY RICKETT

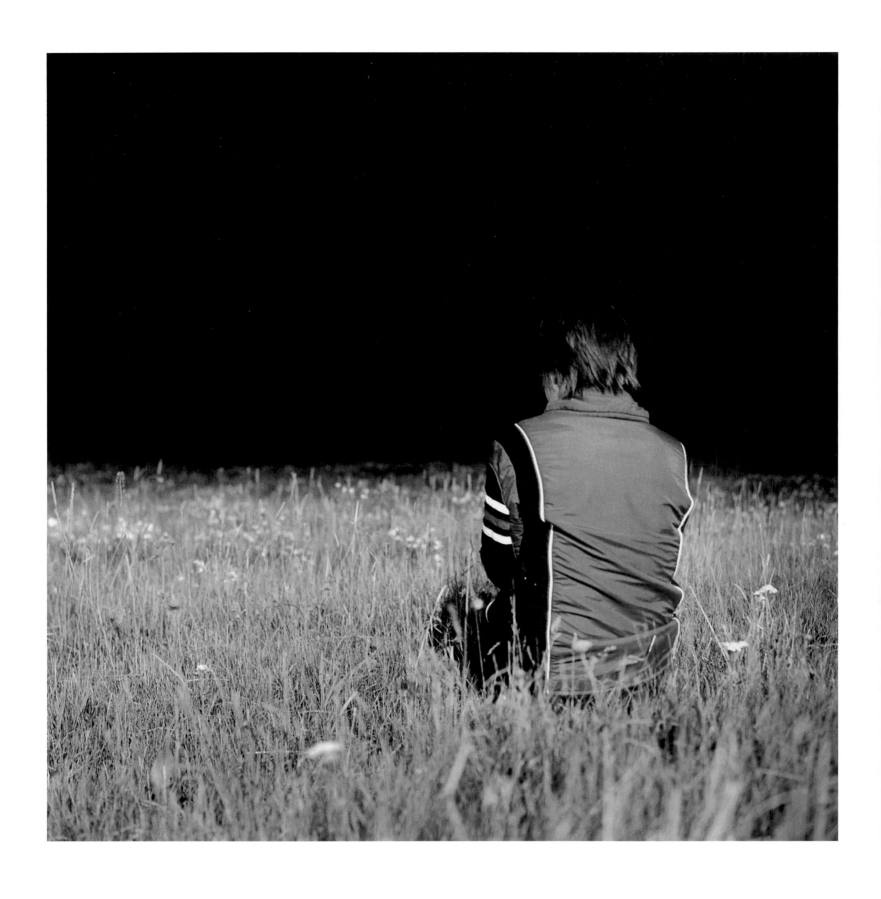

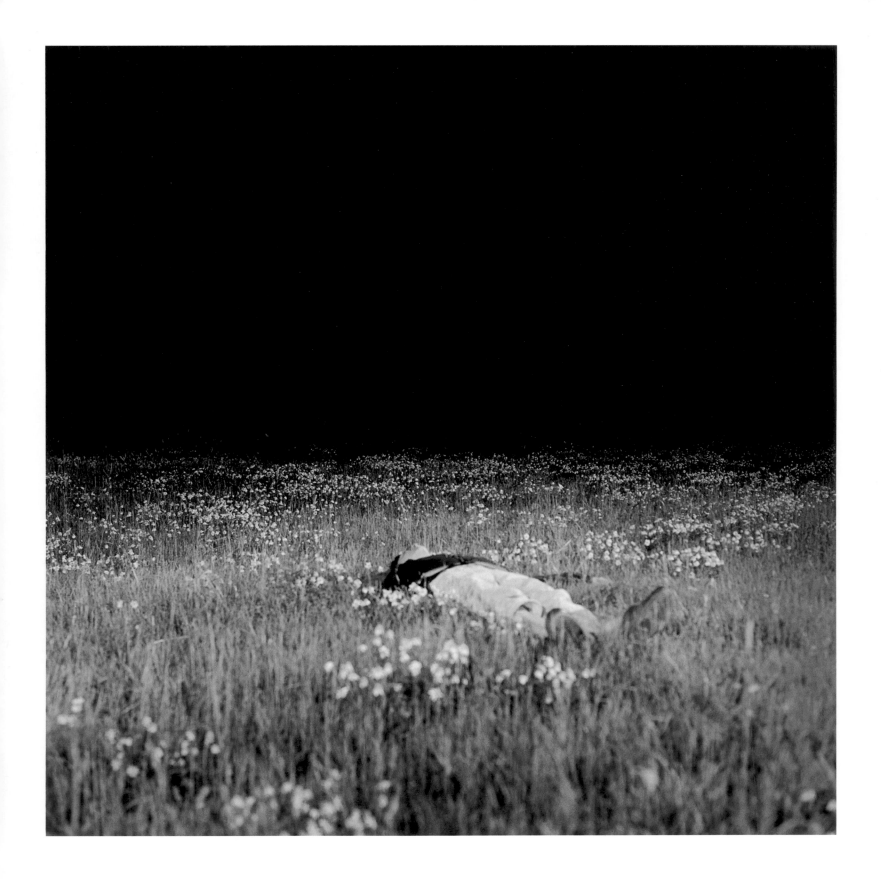

SOPHY RICKETT

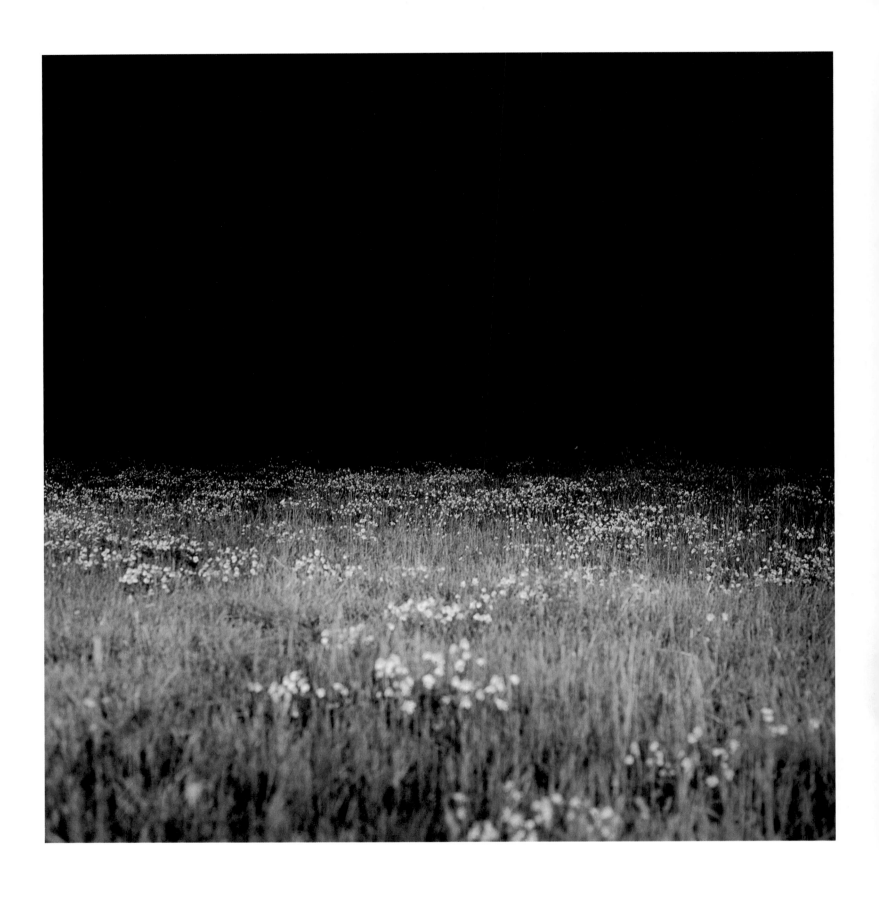

UNTITLED 2 1999 (PART 1+2)

David Shrigley

"IN THE WORK *CARROTS* there is a dichotomy between
growing carrots, which is boring, and growing cacti, which are
inedible. *Your Name Here* depicts another strange scenario.
A snail is selling advertising space on his shell. But what
would you advertise there? Gardening products, maybe?"

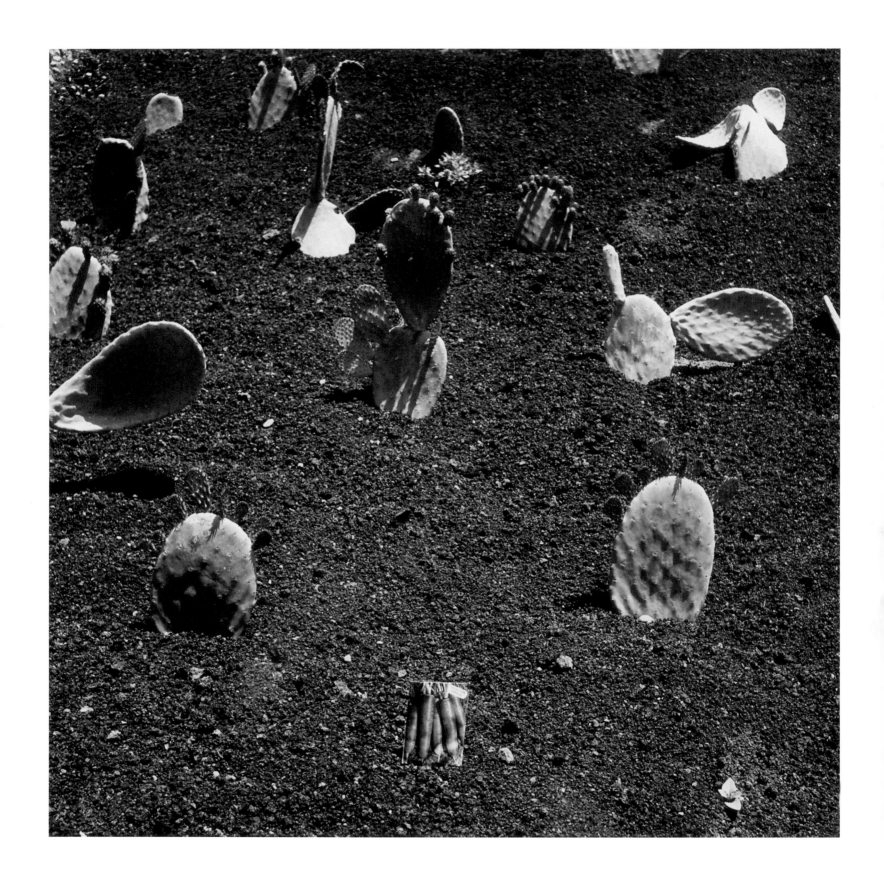

CARROTS 1999 37

DAVID SHRIGLEY

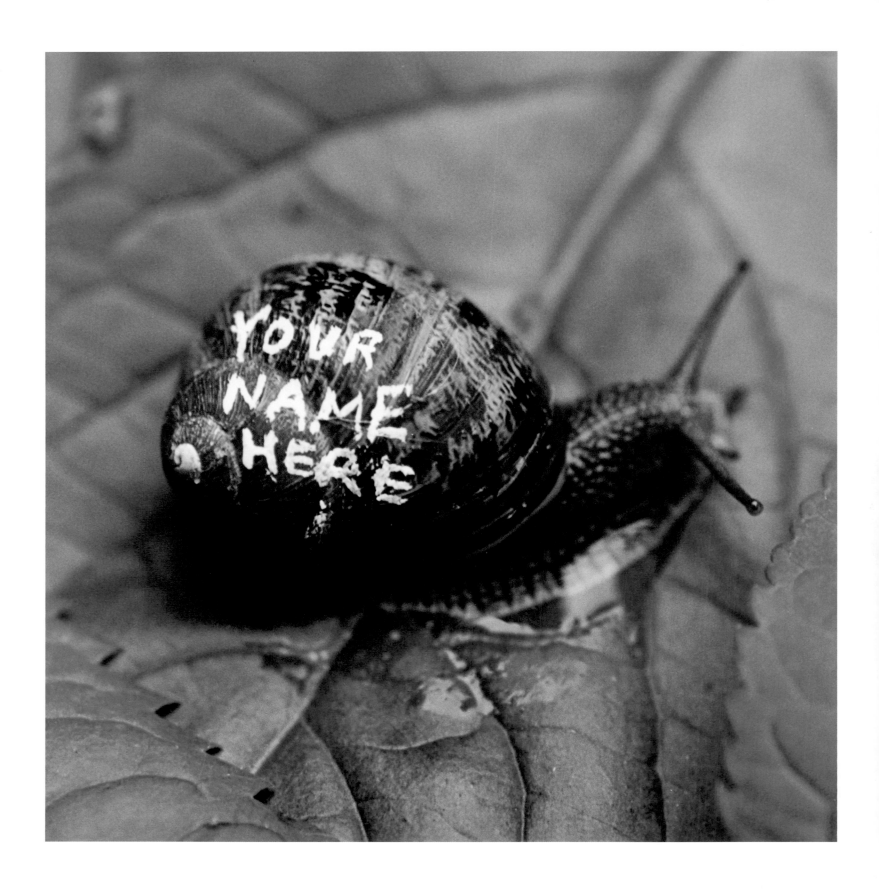

DAVID SHRIGLEY

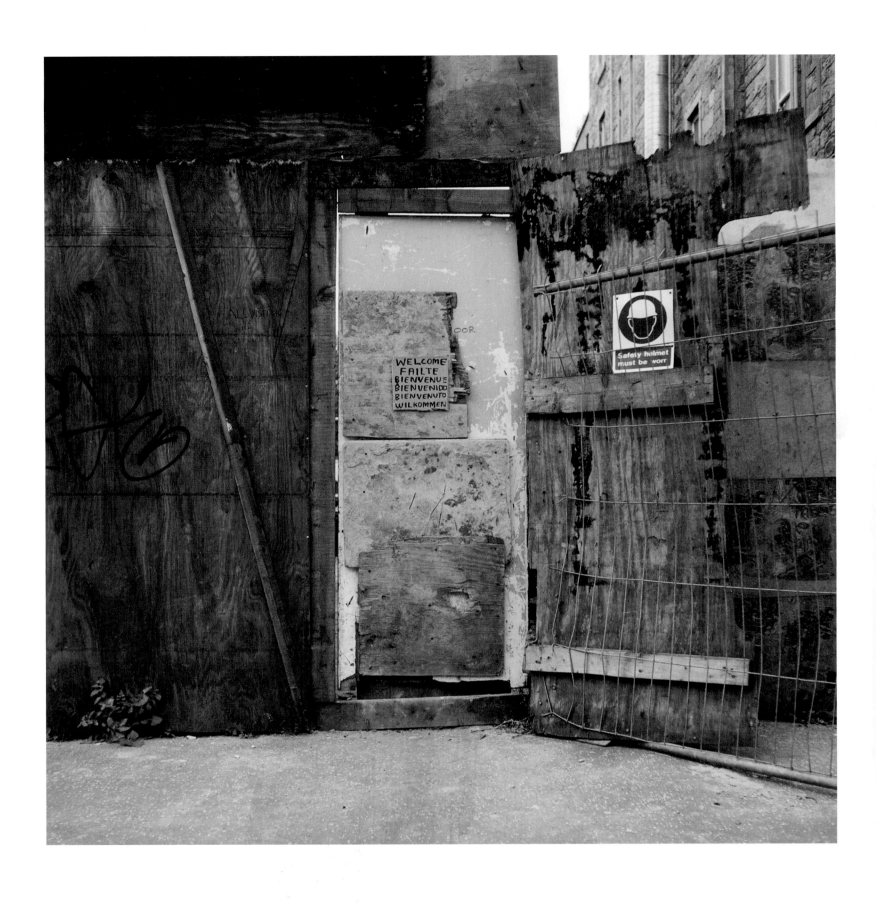

DAVID SHRIGLEY

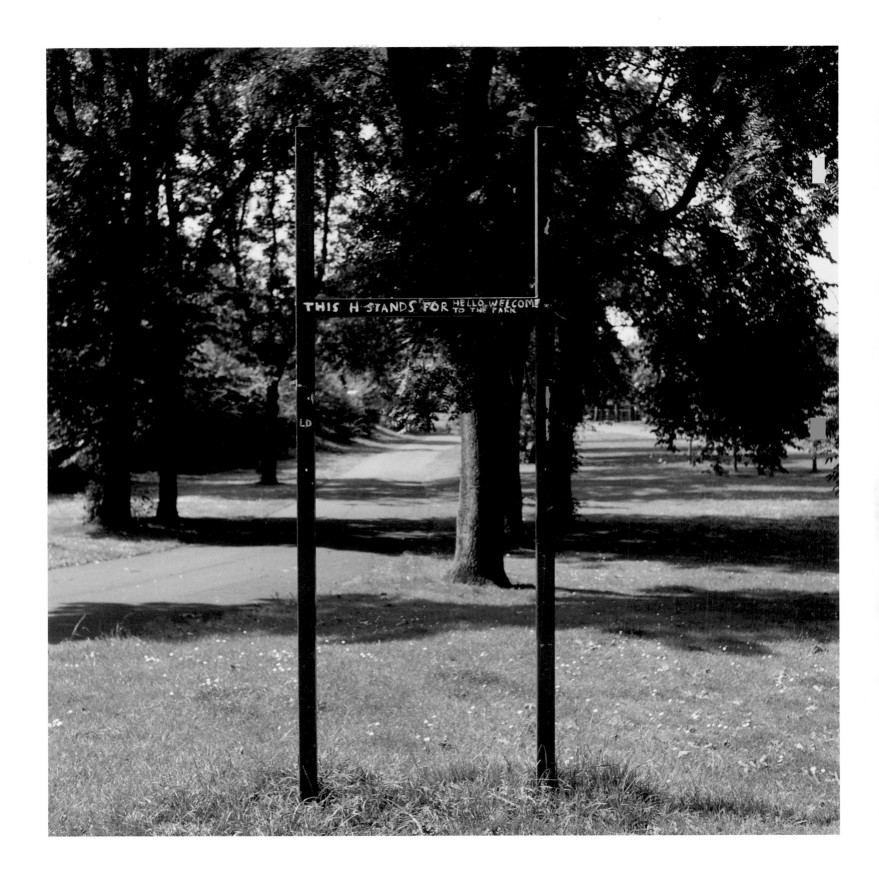

THIS H 1999

43

Bridget Smith

"THE GLAMOUR STUDIOS continue my interest in the calcu-
lated construction that goes into entertainment and our need
for escapism.
All of these sites are permanent film-sets or backdrops for
photographic shoots, used by amateurs and professionals alike
in the world of erotic photography.
I wanted to focus on the details that go into each set. They
are inactive sites to project onto, stripped of any narrative.
The visible signs of construction allow the fantasy to go only
so far and there is a sense of banality, the very banality that
the fantasy is supposed to offset. What I am interested in with
this world as with all my work is the sense of an ideal that is
striven for and yet by its very nature is doomed to remain
unattainable."

GLAMOUR STUDIO (LOCKER ROOM) 1999

45

BRIDGET SMITH

GLAMOUR STUDIO (STABLE) 1999

BRIDGET SMITH

GLAMOUR STUDIO (CHAISE LONGUE) 1999 49

BRIDGET SMITH

GLAMOUR STUDIO (BATHROOM SUITE) 1999 51

Hannah Starkey

"OUR BET IS ON THE YELLOW HORSE and therefore she represents part of our aspirations. Ultimately, she is the first to pass the finishing-post. But as she is jockeyless the bet is void."

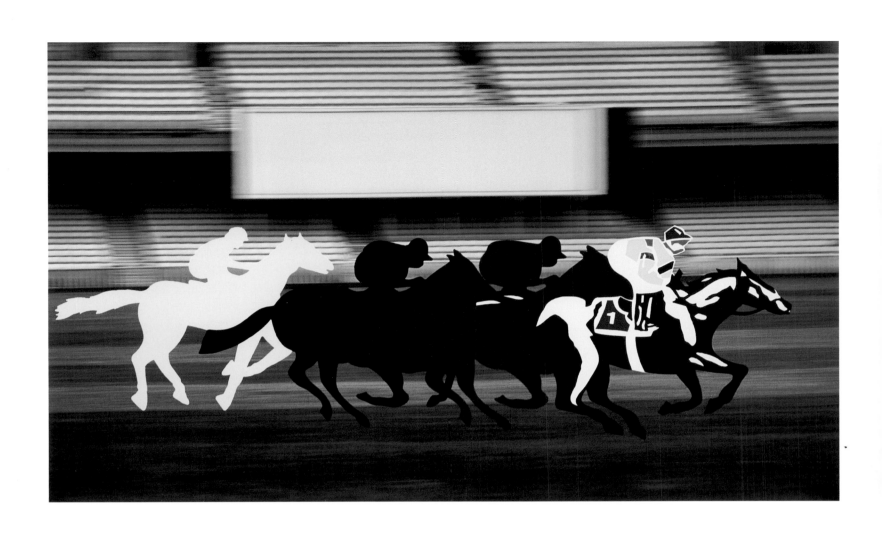

HANNAH STARKEY

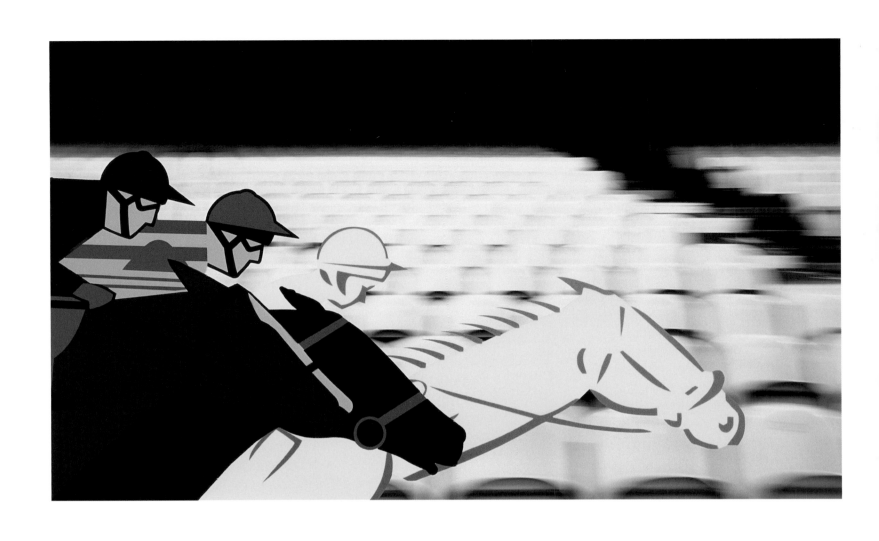

HANNAH STARKEY

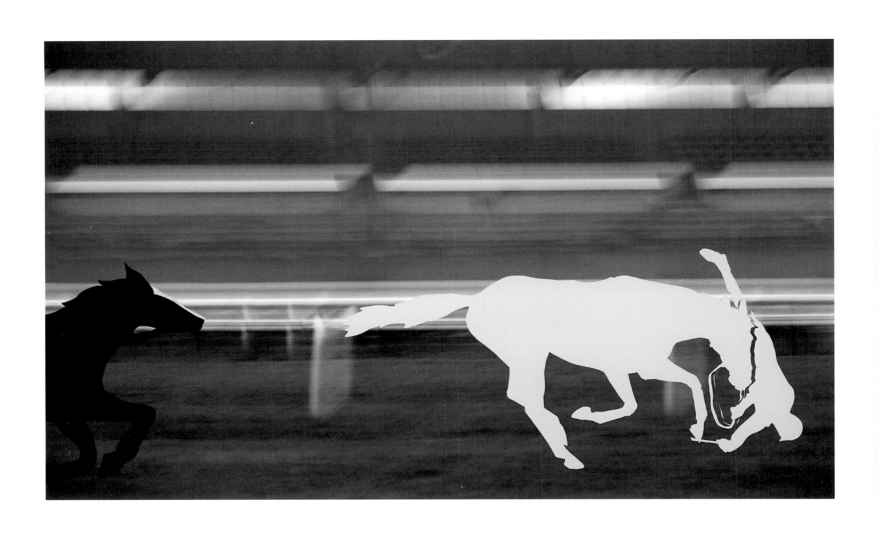

HANNAH STARKEY

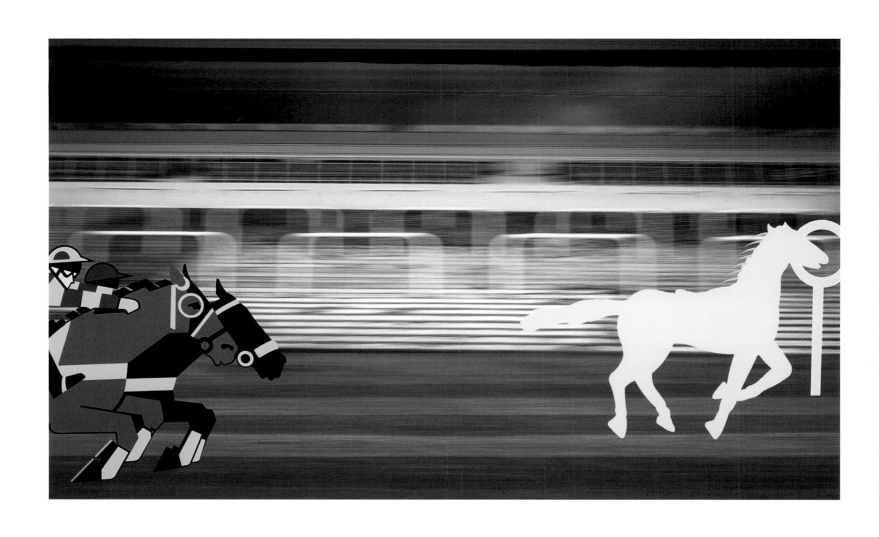

EINFÜHRUNG

DIESES BUCH STELLT SECHS JUNGE BRITISCHE KÜNSTLER UND KÜNSTLERINNEN VOR, die mit dem Medium der Fotografie arbeiten: Tom Hunter, Sarah Jones, Sophy Rickett, David Shrigley, Bridget Smith und Hannah Starkey. Alle sechs Künstler haben 1999 an dem Auftragsprojekt »Making your dreams come true«[1] teilgenommen, und sie alle haben dazu beigetragen, dass die zeitgenössische britische Kunst in den vergangenen Jahren ihre dynamische Kraft entwickeln konnte.[2] Als Künstler der Postmoderne arbeiten sie neben anderen Medien auch mit der Kamera, jedoch nicht um bloß beschreibend und damit aufklärend vorzugehen. Vielmehr ist es ihr Ziel, die erstaunlich deskriptive Kraft der Fotografie einzusetzen, um Fragen aufzuwerfen. Sie überraschen mit ihrer fotografischen Darstellung von Ideen und Ambitionen, Fiktionen und Träumen – und sie verlassen sich darauf, dass wir als Betrachter unsere eigene Vorstellungskraft in ihre Bilder einbringen.[3] Gelingt uns dies, werden wir reichlich belohnt.

SARAH JONES beendete 1996 ihr Studium am Goldsmiths College in London, doch war sie Kunstkritikern und Sammlern bereits durch eine Serie mit dem Titel *The Consulting Room* (Das Sprechzimmer, Abb. S. 6) aufgefallen, die erstmals 1995 in England und Frankreich ausgestellt worden war.[4] Die Fotografien zeigen Nahaufnahmen von Liegen, wie man sie aus den Sprechzimmern von Psychoanalytikern kennt, und sie sind auch tatsächlich im Royal Institute of Psychiatry in London entstanden. Die profanen Details dieser Liegen – die Farben, Stoffe, die Ordnung oder Unordnung von Kissen, Decken oder Kunststoffbezügen – wurden mit einer Großbildkamera festgehalten. Die Bilder erscheinen zunächst als nüchterne Bestandsaufnahme und erschließen sich erst durch eine assoziative Betrachtung. So könnten die dunklen Winkel unterhalb der Liegen seelische Verlorenheit oder unwiederbringlich verschwundene Erinnerungen symbolisieren. Die Wände verweisen auf den institutionellen Raum, in dem Privates und Öffentliches zusammenkommen. Im weiten leeren Raum über der Liege scheinen unheilvolle Enthüllungen zu schweben; gleichzeitig weist der Ausschnitt, den wir gezeigt bekommen, auf die zellenartige Begrenzung hin. Momentan fotografiert Sarah Jones Behandlungsräume in New York.
Ihre in dieser Publikation abgebildeten Arbeiten (Abb. S. 23–29) gehören zu einer Serie, die erstmals 1997 ausgestellt wurde. Die gesamte Serie mit dem Titel *The Dining Room* (Das Esszimmer) zeigt Teenager, Freundinnen aus einer englischen Kleinstadt. Auf den ersten Bildern sind die Mädchen in den Esszimmern ihrer Elternhäuser zu sehen, ohne ihre Eltern, aber in formeller Haltung, als würden sie auf einen Gast warten. Weitere Arbeiten der Serie beziehen auch andere Räume und den Garten mit ein. Die psychologische Dynamik dieser zeitgenössischen Ta-

bleaus ergibt sich aus dem Zusammenspiel vieler Faktoren: der Art, wie junge Mädchen unter-
einander und mit den verschiedenen Aspekten ihrer pubertären Identität umgehen, wie sie sich
in dem von ihren Eltern vorgegebenen Umfeld bewegen und was der Garten und die Welt, die
dahinter liegt, an Möglichkeiten bergen. Wie der *Consulting Room* trägt der *Dining Room* (und
seine späteren Variationen) die Spuren von Stimmen, Blicken und angedeuteten Geschichten.
Hier kommen Diskurse zum Tragen, die auf Cindy Sherman und die von ihr eröffneten psycholo-
gischen Räume verweisen. Aber Sarah Jones besitzt ihren eigenen weiten Bezugsrahmen; so
bezieht sie sich beispielsweise auf die viktorianische Künstlerin Lady Clementina Hawarden.
Sarah Jones hat die Fotografien, die Lady Hawarden um 1860 von ihren Töchtern als Teenager
gemacht hat, sorgfältig studiert.[5] Beide überlassen dem Betrachter die Freiheit in der Ausle-
gung. Eine Vielzahl subtiler Hinweise gibt uns die Möglichkeit, verschiedene Szenarios zu ent-
werfen. Wie Sarah Jones selbst bemerkt: »In diesen Bildern […] geht es darum, was geschieht,
wenn wir uns erinnern oder uns bewusst machen, was wir begehren oder einst begehrt haben.«

Auch SOPHY RICKETT schuf eine Serie mit Schwarzweißfotografien, die unsere Wahrnehmung
der in dieser Ausstellung präsentierten Arbeiten womöglich beeinflusst. *Pissing Women*
(Pissende Frauen, 1995) zeigt junge, gut gekleidete Frauen, die an bekannten Londoner Orten
ihre Röcke heben und in männlicher Haltung urinieren – eine humorvolle feministische Spitze
gegen typisches machistisches Verhalten. Einige Elemente dieser frühen Serie finden sich auch
in den Arbeiten, die gegen Ende von Ricketts Studienzeit am Londoner Royal College of Art und
danach entstanden sind. Die Nacht, die Stadt, künstliches Licht, die Vorstellung von Gefahr und
die Andeutung alltäglicher, unbewusster Zwänge sind die Themen ihres späteren Werks. Der
schwarze Nachthimmel dieser Arbeiten ruft uns die Dunkelheit unter den von Sarah Jones foto-
grafierten Liegen ins Gedächtnis. Das sind Orte für Träumereien – unbestimmte Räume, ange-
siedelt in einem Niemandsland, wie es entlang der Zufahrtsstraßen außerhalb Londons zu finden
ist. In diesem Gebiet der Autobahnen, der Verkehrsinseln und des Kreisverkehrs wird nur ein
schmaler, ungepflegter Landschaftsstreifen von künstlich wirkendem Sonnenlicht erhellt. Einzel-
ne, isolierte Gestalten, schlafend oder sitzend, beleben die Szene und lenken unseren voyeuri-
stischen Blick auf ihre unbekannten Träume oder Gedanken. Als Sophy Rickett sich einmal zu
diesen Figuren äußerte, stellte sie die Frage: »Lähmt sie die Umgebung, die keine Fluchtmög-
lichkeit bietet, oder betrachten sie die dunkle Weite der Nacht und denken über ihre Geheim-
nisse nach und die unglaublichen Möglichkeiten, die sie birgt?«

Spätere Arbeiten entstanden in Schottland (auf einer Pappelschonung in der Nähe von Dundee), im Lake District (Grizedale Forest) und in der atemberaubenden, hyperrealistischen oder supermodernen Landschaft um Los Angeles. In Ricketts Fotografien werden diese Orte einander ähnlich. Ihrer eigenen Erfahrung nach erlebt sie das Entdecken von Orten so, »als ob man auf eine alte Erinnerung stößt. Man erkennt etwas wieder, von dem man gar nicht wusste, dass man es vergessen hatte. Meine Arbeiten sind wahrscheinlich viel stärker durch meine mentale Verfassung geprägt als durch den Ort, an dem ich gerade bin. Seelenzustände sind viel schwieriger einzufangen als geografische Orte.«[6]

Auch HANNAH STARKEY hat am Royal College of Art in London studiert. Der Durchbruch gelang ihr mit Arbeiten, die sich stark von denen unterscheiden, die für »Making your dreams come true« entstanden sind. Man kann Hannah Starkey als neuen, dem 21. Jahrhundert gemäßen Typus des »peintre de la vie moderne«, wie ihn Charles Baudelaire beschrieben und Edouard Manet verkörpert hatte, bezeichnen. Wie Manet stellt sie das zeitgenössische Leben dar und arbeitet dabei Gefühlslagen heraus, die bislang noch nicht als Stoff für eine künstlerische Auseinandersetzung erkannt wurden. Ebenfalls wie Manet arbeitet Hannah Starkey mit Spiegeln innerhalb ihrer Bildräume. So zeigt eine Arbeit aus dem Jahr 1999 (Ohne Titel – März 1999, Abb. S. 9) einen Spiegel in einem Damenankleideraum oder einer Toilette und eröffnet uns damit ein ganzes Spektrum an vieldeutigen, widersprüchlichen und verwirrenden psychologischen Möglichkeiten. Wie Sarah Jones erzeugt Hannah Starkey Bilder, in denen jegliche Handlung eliminiert ist oder höchstens auf das Flackern eines Feuerzeugs reduziert wird – Geschichten, die allenfalls flüchtig erahnt, keinesfalls jedoch wirklich fassbar werden. Für ihre Inszenierungen engagiert sie professionelle Schauspieler und wählt für die Großstadt charakteristische Schauplätze: einen Videoshop, einen Aufenthaltsraum, eine Bar, ein Café, einen Bus, einen Weight Watchers Club, einen Streifen städtischen Brachlands. Für »Making your dreams come true« fotografierte sie die Fenster eines Wettbüros, die voller Werbematerial hängen. In digital aufgenommenen Bildern erzählt sie eine Geschichte über ein Pferderennen: »Wir haben auf das gelbe Pferd gesetzt, das deshalb unseren Ehrgeiz verkörpert. Schließlich geht es als erstes durchs Ziel – aber ohne Jockey. Die Wette ist ungültig.«

BRIDGET SMITH studierte, wie Sarah Jones, am Goldsmiths College in London. Und wie bei Hannah Starkey gibt es in ihren Arbeiten Bezüge zu Manet. So etwa bei ihren ersten Arbeiten zu den mit luxuriösen Vorhängen ausgestatteten Proszenien alter Kinos (1994), die an Manets Welt der bürgerlichen Vergnügungsstätten anknüpfen. Doch die prunkvoll glänzenden Vorhänge bleiben in Smiths farbenprächtigen Abzügen geschlossen, die Betrachter können sich ihre eigenen Geschichten ausmalen. Smith richtete ihre Aufmerksamkeit auch auf die so genannten »Glamour-Studios« der Provinzstädte, wo die Fotografen Porträts anboten, bei denen man sich

etwa als Sportsmann, als verwöhntes Filmsternchen oder Ähnliches ablichten lassen konnte. Doch nun posiert dort niemand mehr, die Kulissen bleiben leer, und wir bleiben allein mit einer selbst gebastelten Maschinerie der Träume.

Zuletzt fotografierte Bridget Smith in Tokio die fremdartige Verschlossenheit öffentlicher Orte und Zeichen. Ein in ihrem Werk einflussreicher Ort ist Las Vegas, die Stadt der käuflichen Illusionen, wo ihr bemerkenswerte Dokumentationen der je nach Blickwinkel tollkühnen oder auch dreist überzogenen Wunschvorstellungen gelungen sind. Sie zeigt das Bedürfnis nach Illusion als grundlegende menschliche Eigenschaft und als Leitmotiv der anspruchsvollen Comédie humaine.

TOM HUNTER machte seinen Abschluss am Royal College of Art, studierte jedoch zuvor, wie Sophy Rickett, am London College of Printing, wo er sich bereits einen Namen machen konnte. Sein dortiges Abschlussprojekt nannte er *Ghetto* (1994): ein großes, dreidimensionales Modell von Häusern in Hackney, einem Stadtteil im Londoner East End, in dem damals viele Künstler und Hausbesetzer lebten. Der Titel war durch einen Artikel in einer Lokalzeitung inspiriert, in dem Hackney als ein »vom Verbrechen zerrüttetes, verfallenes Ghetto« bezeichnet wurde.[7] Hunter lässt den Betrachter durch die Fenster dieser Reihenhäuser auf beleuchtete Farbdias der Inneneinrichtung blicken. Ein ganzes Jahr arbeitete Hunter an seinem Modell, das heute ein viel beachtetes Ausstellungsstück des Museum of London ist und als Kernstück der Kunstschau »Creative Quarters« (2001) gezeigt worden war. Hunter wandelte das so genannte »Ghetto« zu einem überzeugenden Bild einer lebendigen, kreativen Gemeinschaft.

Seine Abschlussarbeit am Royal College of Art ist eine Fotoserie mit dem Titel *Persons Unknown* (Unbekannte Personen), die in der Folgezeit vielfach ausgestellt und publiziert wurde. Es handelt sich um Porträts von Hausbesetzern in Hackney – jenen oftmals als »asoziale Parasiten« angesehenen Menschen –, die Hunter wie Kompositionen von Vermeer in Szene setzte und mit seiner 5x4-Inch-Kamera fotografierte. *Woman Reading a Possession Order* (Frau beim Lesen einer Räumungsklage; Abb. S. 11) stellt das wichtigste Foto der Reihe dar, basierend auf Vermeers *Briefleserin am offenen Fenster*. Die sorgfältig ausgeleuchtete Szene folgt der Komposition des Gemäldes, doch ist anstelle der Fruchtschale ein Baby zu sehen und das Fenster ist geschlossen. Mit Räumungsklagen werden Hausbesetzer aufgefordert, das Gebäude bis zu einem bestimmten Datum zu verlassen. Die öffentlichen Behörden stellen die Klagen an »unbekannte Personen«, die »Unknown Persons« aus.

Hunter ist viel gereist, ein Jahr ist er unter anderem in einem britischen Doppeldeckerbus durch Europa gefahren. Seine Bilder von Reisenden – besonders von Ravern, die von Land zu Land ziehen – drücken ebenfalls eine deutliche Sympathie für Menschen und Gruppen aus, denen für gewöhnlich die gesellschaftliche Anerkennung verweigert wird. »Obwohl diese Menschen nicht aus reichen Familien stammen und über keine großen Besitztümer verfügen, sind sie trotzdem stolz auf die Landschaft, in der sie leben und der sie angehören [...] Meine Bilder zeigen, dass sie die Träume der alten gesellschaften Elite leben.«

DAVID SHRIGLEY beschäftigt sich unter anderem, wie Tom Hunter, mit Installationen und Objektkunst. Im neu eröffneten Wellcome Wing im Londoner National Museum of Science and Industry sind mehrere seiner Werke zu sehen – darunter eine silberne Trophäe, die für Leistungen auf einem eher ungewöhnlichen Gebiet verliehen wird: dem Fluchen.

Shrigley ist außerdem ein ausgezeichneter Fotograf, Zeichner, Bildhauer und Schriftsteller. Er absolvierte die Klasse Enviromental Sculpture an der Glasgow School of Art, und, obwohl er nicht im angesehenen Fine Art Department studierte, bewegt er sich souverän zwischen verschiedenen Medien und Kontexten. In seiner Herangehensweise bleibt er stets humorvoll, hintergründig und erfinderisch. Zu seinem Verständnis von Fotografie erklärt Shrigley: »Die Arbeit *Carrots* zeigt den Unterschied zwischen dem Anbau von Karotten, was eine langweilige Angelegenheit ist, und der Zucht von Kakteen, die allerdings nicht essbar sind. *Your Name Here* zeigt eine andere befremdliche Situation. Eine Schnecke verkauft Werbefläche auf ihrem Häuschen. Aber für was würden Sie dort werben? Gärtnerei-Produkte etwa?«

MARK HAWORTH-BOOTH ist Kurator für Fotografie am Victoria and Albert Museum, London.

1. Die 24 abgebildeten Fotografien (S. 15–59) sind Teil der Sammlung der BMW Financial Services Group Great Britain. Die Werke wurden 1999 von der BMW Financial Services Group GB unter dem Thema »Making your dreams come true« in Auftrag gegeben.

2. 12 von diesen Werken sind Teil der National Collection of the Art of Photography am Victoria and Albert Museum, London.

3. Alle Vergleichsabbbildungen im Text sind nicht im Auftrag von BMW entstandene Werke der Künstler.

4. Werke von Sarah Jones aus dieser Reihe wurden unter anderem von dem privaten Sammler Charles Saatchi erworben, dessen Galerien und Ausstellungen in den letzten Jahren wesentlich zur Förderung experimenteller visueller Kunst in Großbritannien beigetragen haben.

5. Die Leitung des Huis Marseille in Amsterdam vollbrachte eine Glanzleistung, als sie die Werke der beiden Künstlerinnen Sarah Jones und Lady Clementina Hawarden zusammen ausstellte.

6. »Kate Bush in Conversation with Sophy Rickett«, in: *Sophy Rickett Photographs*, Ausst.-Kat. Emily Tsingou Gallery, London 2001.

7. »Tom Hunter«, Interview von Jean Wainwright, in: *Hot Shoe International*, September–Oktober 1999, S. 18–22.

TOM HUNTER

Born in Bournemouth, UK, 1965.
Currently lives and works in London.

Education

1994	London College of Printing, B. A. (First Class Honors)
1994–1997	Royal College of Art, London, M. A.

Solo Exhibitions

2000
"Life and Death in Hackney", White Cube, London

1997
"Tom Hunter, Retrospective", Photofusion Gallery, London
"Persons Unknown" and "Travellers", Cafe Alba Gallery, London
"Persons Unknown", Holly Street Public Arts Trust Gallery, London
"Travellers", The Bell Street Gallery, Wiltshire, UK

1996
"Portrait of Hackney", Cafe Alba Gallery, London

Group Exhibitions

2001
"Tracking", Kent & Vicki Logan Galleries at California College of Arts and Crafts, Oakland, USA
"Creative Quarters", Museum of London, London
"Look Out", Pitshanger Manor Gallery, London

2000
"Parallax", Sandroni Rey Gallery, Venice, USA
"Residual Property. Tom Hunter, Mary MacLean, Jason Oddy, Elisa Sighicelli", Portfolio Gallery, Edinburgh

1999
"Neurotic Realism (Part Two)", The Saatchi Gallery, London
"Threshold", The Travelling Gallery, Edinburgh, et al.
"Housing and Homeless", The Candid Gallery, London

1998
"Persons Unknown", M. A. C. Gallery, Birmingham
"Summer Show", The Paton Gallery, London
"Les Anglais vus par les anglais", Rencontres Internationales de la Photographie d'Arles
"Ikon Touring", Touring exhibition
"Campaign Against Living Miserably", Royal College of Art, London
"Factory Built Homes", Shoreditch Biennale, London
"Whitechapel Open", The Tannery, London

1997
"Modern Narrative – The Domestic and the Social", ArtSway – Contemporary Visual Arts in the New Forest, Sway, UK
"Best of Royal College of Art", Summer Show, Villa Restaurant, London
"Summer Show", Royal College of Art, London

1996
"Progress", Royal College of Art, London

1995
"Interim Show", Royal College of Art, London

1994
"Top Marks", The London Institute, London
"Degree Show", London College of Printing, London

Bibliography

2001
Nilsson, Håkan, Daniel Buren, Maria Larsson, Andreas Engström, Halldór Björn Runólfsson. *Experience. Dissolution*, Göteborgs International Art Biennal, Konsthallen Göteborgs 2001

2000
'Parallax', *Los Angeles Times*, 31 March 2000
Look Out, curated by Peter Kennard for Art Circuit Touring Exhibitions, *DPICT*, 2000

1999
Timms, Robert, Bradley, Alexandra and Hayward, Vicky, *Young British Art: The Saatchi Decade*, Booth-Clibborn Editions, 1999
Gayford, Martin, "Who Cares About Labels?", *The Spectator*, 29 September 1999, p. 67
Wainwright, Jean, "Tom Hunter (Interview)", *Hotshoe*, September/October 1999, pp. 18–22
Withers, Rachel, "Basket Cases", *Artforum*, September 1999, vol. XXXVIII, No. 1, p. 54
Aidin, Rose. "So Was It Really a Sensation?", *The Sunday Times*, 22 August 1999
McEwen, John, "Too Much Irony and Not Enough Genuine Neurosis", *The Sunday Telegraph*, 19 September 1999, p. 9
Cork, Richard, "A Case of Less Matter, More Rat", *The Times*, 15 September 1999, p. 38
P. E., "New Neurotic Realism", *Flash Art*, Summer 1999, vol. xxxii, no. 207
"Threshold", *Art Monthly*, July–August 1999, no. 228, pp. 35–37

1998
Price, Dick, "The New Neurotic Realism", The Saatchi Gallery, 1998
Tait, Simon, "John Kobal Photographic Portrait Award 98", Zelda Cheatle Press, 1998
"Night of the Hunter", *British Journal of Photography*, October 1998

"Tom Hunter, Tower Block Series", *Siski*, Ocotber 1998
"John Kobal Winner", *The Guardian*, 17 October 1998
"Tower Block" *World of Interiors*, June 1998
"Sorry Damien, However Hard You Try, You've Become Passé", *The Independent*,
30 May 1998
"High Rise Families", *Creative Camera*, May 1998
"Hackney Empire", *The Face*, May 1998
"Let's Do Lunch", *The Times*, 17 January 1998
"This Caravan Life", *The Guardian*, 16 January 1998

1997 "Life Story", *The Guardian*, 21 November 1997
 "Photographic Shrine", *Country Life*, 2 November 1997
 "Home Hunter", *Blue Print*, November 1997
 "Kodak Exposed", *Dazed and Confused*, November 1997
 "Gypsy King", *Time Out*, 24–31 October 1997
 "Squatting Pretty", *The Independent*, 15 October 1997
 "Going Dutch in Hackney", *The Times Magazine*, 13 September 1997
 "Winning Portfolio", *British Journal of Photography*, 3 September 1997
 "Tower Block Project", *Architects Jounal*, 7 August 1997
 "Painters Stainers Prize For Photography", *British Journal of Photography*, 15 July 1997
 "In the Shadow of Saatchi", *Times Higher Educational Supplement*, 13 June 1997

1996 "Fuji/Joe's Basement RCA Awards", *Hotshoe*, May 1996
 "Hunter Catches Prize", *British Journal of Photography*, 29 May 1996

1995 "Portraits", *This Way Up*, July 1995

1994 "Extraordinary Scale Model", *Art Review*, December 1994
 "Shooting Star", *British Journal of Photography*, 30 November 1994
 "London Lives – Tom Hunter", *Time Out*, 16 November 1994
 "London Fields East the Ghetto", *The Guardian*, 16 June 1994
 "Youthful Eyes", *British Journal of Photography*, 15 June 1994

 Seabourne, Mike, "Photographers London", The Museum of London (n. d.)
 Ross, Catherine, "Museum of London", Philip Wilson Foundation (n. d.)
 Williams, Val, "Modern Narrative: The Domestic and the Social", ArtSway (n. d.)
 Williams, Val, "Factory Built Homes", Arts Council (n. d.)

Awards

1998 John Kobal Photographic Portrait Award

1996 Royal College of Art First Year Award for Best Photography (Fuji Film UK Ltd.)

1995 The Tredou Arts and Culture Award

Collections

 BMW Financial Services Group Great Britain Collection, Hampshire, UK
 Hackney Museum, London
 KLM Royal Dutch Airlines, The Netherlands
 Saatchi Collection, London
 Victoria and Albert Museum, London
 20th Century Gallery, Museum of London, London

SARAH JONES

Born in London, 1959.
Currently lives and works in London.

Education

| 1978–1981 | Goldsmiths College, London, B. A. (Honors) |
| 1994–1996 | Goldsmiths College, London, M. A. |

Solo Exhibitions

2000 Le Consortium, Dijon (as part of the festival "I Love Dijon")
Huis Marseille, Amsterdam

1999 Museum Folkwang, Essen, Germany
Anton Kern Gallery, New York
Centre for Photography, Universidad de Salamanca
Museo Nacional Centro de Arte Reina Sofia, Madrid
Maureen Paley/Interim Art, London
Jerwood Space, London

1998 Galerie Anne de Villepoix, Paris
Ecole supérieure des Beaux-Arts, Tours, France
"Sites", Sabine Knust Galerie, Munich

1997 Le Consortium, Dijon
Maureen Paley/Interim Art, London

1995 "Consulting Room", Galerie du Dourven, Trédrez-Locquémeau, France
"Consulting Room (Couch)", Camerawork Gallery, London

1993 Hales Gallery, London

1988 Watershed Arts Centre, Bristol

1987 F-stop Gallery, Bath, UK

Group Exhibitions

2000 "Les Trahisons du modèle", Galerie Nei Liicht, Dudelange, Luxembourg
"Intersection I: Intimate/Anonymous", Espace d'art Contemporain HEC, Jouy-en-Josas, France
"docudrama", Bury St. Edmunds Art Gallery, Bury St. Edmunds, UK
"Pause/Pose", Galerie Anne de Villepoix, Paris
"Wooden Heart", AVCO, London
"Quotidiana", Castello di Rivoli – Museo d'Arte Contemporanea, Rivoli–Turin

1999 "Another Girl Another Planet", Lawrence Rubin Greenberg Van Doren Fine Art, New York
"3rd International Tokyo Photo Biennial", Tokyo Metropolitan Museum of Photography
"Dreamlands", Portfolio Gallery, Edinburgh

1998 "F comme Photographie", Fri-Art – Centre d'art contemporain, Fribourg, Switzerland
"dijon/le consortium.coll, tout contre l'art contemporain", Musée national d'art moderne – Centre Georges Pompidou, Paris
"Shot Without Reason", Bloom Gallery, Amsterdam
"Sorted", Ikon Gallery, Birmingham
"Made in London", Museu de Electricidade, Lisbon
"The Erotic Sublime (Slave to the Rhythm)", Galerie Thaddaeus Ropac, Salzburg
"Family Credit", Collective Gallery, Edinburgh

1997 "Portrait", Maureen Paley/Interim Art, London
"Dramatically Different", Galeries du Magasin – Centre national d'art contemporain de Grenoble
"Strange Days", Gian Ferrari Arte Contemporanea, Milan
"On the Bright Side of Life: Zeitgenössische britische Fotografie", Neue Gesellschaft für bildende Kunst, Berlin, et al.
"Bill Henson, Sarah Jones, Philip-Lorca DiCorcia", Galerie Gebauer, Berlin
"Jennifer Bornstein, Jenny Cage, Anna Gaskell, Dana Hoey, Sarah Jones, Valérie Jouve, Gillian Wearing", Galerie Anne de Villepoix, Paris
Moulin Saint-James, Printemps de Cahors, Cahors, France

1996/97 "A. C. E.!", Arts Council Collection, Hatton Gallery, Newcastle, UK, et al.
"New Contemporaries", Tate Gallery Liverpool; Camden Arts Centre, London

1995 "Sick", 152c Brick Lane, London
"Nobby Stiles", Vandy Street, London

1994 "Foto 2", 152c Brick Lane, London
"Dad", Gasworks Gallery, London

1991 "Slow Horses", St. James, London

1990 "Next Phase", Tobacco Dock, London

1989 "Constructed Imagery", Plovdiv Gallery, Plovdiv, Bulgaria

1988 Untitled Gallery, Sheffield
 The Photographers' Gallery, London

Bibliography

2000 "Verschil in overeenkomst", *Spits*, 3 May 2000
 Steketee, Hans, "De jonge vrouw als beeldhouwwerk", *NRC Handelsblad*, 3 May 2000
 Van Hooff, Dorothée, "Mysterieuze tableaux vivants", *Residence*, May 2000
 "Huis Marseille', *Holland Horizon*, March 2000
 Slyce, John, "Sarah Jones", *artext*, no. 68, February/April 2000
 Bahners, Patrick, "Ist die minderjährige Tochter der Lady aus erster Ehe?", *Frankfurter Allgemeine Zeitung*, 18 February 2000
 "Räume & Gesten", *Foyer*, February 2000
 Weckesser, Markus, "Stille Leben", *Intro*, February 2000
 "Museum Fo kwang Essen: Sarah Jones, Farbfotografien", *Profifoto*, January/February 2000
 Kröner, Magdalena, "Farbiges Vakuum", *die tageszeitung*, 24 January 2000
 "Farbfotografien Sarah Jones", *Elle Plus*, January 2000
 Heald, Claire, "Under Surveillance", *arteast.co.uk*, 2000
 Kröner, Magdalena, "Sarah Jones", *Camera Austria International*, no. 70, 2000

1999 Furniss, Jo-Ann, "Village of the Bland", *The Face*, no. 34, November 1999
 Archer, Mike, "Sarah Jones, Jerwood Gallery", *Artforum*, no. 2, vol. 38, October 1999
 Beech, Dave, 'Sarah Jones", *Art Monthly*, no. 230, October 1999
 Wainwright, Jean, "Sarah Jones, The Jerwood Space, London", *Hotshoe International*, September/October 1999
 Herbert, Martin, "Sarah Jones", *Time Out*, no. 1515, 1–8 September 1999
 Siegel, Katy, "Another Girl, Another Planet, Lawrence Rubin Greenberg Van Doren, New York", *Artforum*, no. 1, vol. 38, September 1999
 "Readings", *Harper's*, June 1999, p. 21
 Slyce, John, "Sarah Jones: Spatial Alienations", *Flash Art*, no. 206, vol. 32, May/June 1999
 Townsend, Chris, "Dreaming of Me", *Hotshoe International*, May/June 1999
 Johnson, Ken, "Art in Review: Another Girl, Another Planet", *The New York Times*, 16 April 1999
 Beaumont, Susanna, "Interior Drama", *The List*, 18 February – 4 March 1999
 Bradley, Alexander, "Sarah Jones", *Metropolis M*, no. 5, 1999

1998 Blazwick, Iwona, "Feel No Pain. Lifestyle Photography and Photography as Lifestyle", *Art Monthly*, no. 221, November 1998
 Imbert, Pierre, "Sarah et les jeunes Filles", *La Nouvelle République*, 15 September 1998
 Russell Taylor, John, "The Big Show: Sorted", *The Times Metro*, 5–11 September 1998
 Mahoney, Elizabeth, "Family Credit", *Art Monthly*, no. 219, September 1998
 Crabtree, Amanda, "Malade Imaginaire?", *Art Monthly*, no. 215, April 1998
 Townsend, Chris, "Openings. Sarah Jones", *Artforum*, no. 7, vol. 36, March 1998
 Guerrin, Michel, "Les jeunes Filles en fleurs photographiées par Sarah Jones", *Le Monde,* 14 February 1998
 Maillet, Florence, "Sarah Jones. Cherchez le Garçon", *Beaux-Arts Magazine,* no. 165, February 1998
 Lindgaard, Jade, "Teenage Fan-club", *Les Inrockuptibles*, no. 133, 13 January 1998
 Durand, Regis, "Dark Foundations", *art press*, no. 231, January 1998
 Coleman, Sarah, "Capturing Adolescence: Three Shows in London – Sarah Jones at Interim Art", *Photo Metro,* no. 148, vol. 16, 1998
 Townsend, Chris, *Vile Bodies: Photography and the Crisis of Looking*, Munich 1998

1997 *Creative Camera*, December 1997/January 1998
 Thorp, Mo, "Dark Underside", *make*, no. 76, June/July 1997
 Bernard, Kate, "Sarah Jones: New Work – The Dining Room", *Hot Tickets*, 13 March, p. 43
 Kent, Sarah, "Sarah Jones", *Time Out*, March 1997, p. 49
 Patrizio, Andrew, "Sarah Jones", *Galleries,* March 1997, p. 15
 Troncy, Eric, *Documents sur l'Art*, Dijon 1997

1995 Searle, Adrian,"Camerawork", *Time Out*, August 1995
 Cavell, Stanley, "Cabinet de Consultation", *Arts Plastiques,* May 1997

1994 Lillington, David, "Foto 2", *Time Out*, March 1994

1993 Kivland, Sharon, *Untitled Magazine*, Winter 1993, p. 10

Awards

1995 Office Departemental de Developpement Culturel, Dourven, France

1994 K Foundation Award

1990 Eastern Arts Bursary (Artist in Residence, Camp JMI School, Herts, UK)

1985 Greater London Arts Board

Collections

The Arts Council of England
Atara Investments, Israel
Big Flower Press, New York
BMW Financial Services Group Great Britain Collection, Hampshire, UK
Le Consortium, Dijon
Museum Folkwang, Essen, Germany
FRAC Nord – Pas de Calais, France
FRAC Region Poitou Charentes, France
Koninklijke PTT Nederland NV, The Netherlands
Huis Marseille, Foundation for Photography, Amsterdam
Museum of Modern Art, San Francisco
Neuberger Berman LLC, New York
Refco Inc., Chicago
Saatchi Collection, London
Universidad de Salamanca
Simmons & Simmons, London
Tate Modern, London
Tishman Speyer Properties Inc., New York
Victoria and Albert Museum, London
Paul Wilson Collection, London

SOPHY RICKETT

Born in London, 1970.
Currently lives and works in London.

Education

1990–1993 London College of Printing, B. A. (Honors) Photography
1997–1999 Royal College of Art, London, M. A. Fine Art Photography

Solo Exhibitions

2001 Emily Tsingou Gallery, London
 DCA – Dundee Contemporary Arts, Dundee, UK

1999 Emily Tsingou Gallery, London

Group Exhibitions

2001 The Herzliya Museum of Art, Tel Aviv
 "Infralimina.", Stills Gallery, Edinburgh
 "Where Are We?", Victoria and Albert Museum, London
 "Night on Earth", Städtische Ausstellungshalle Münster, Germany
 "The Fantastic Recurrence of Certain Situations: Recent British Art and Photography",
 Sala de Exposiciones
 del Canal de Isabel II, Madrid

1999 "Common People: British Art from Phenomenon to Reality", Palazzo Re Rebaudengo,
 Guarene d'Alba, Italy
 "Evidence of Existence", The Bracknell Gallery, South Hill Park Arts Centre, Ringmead,
UK
 "Near and Elsewhere", The Photographers' Gallery, London
 "Evidence of Existence", Kunstraum Siegert, Basel
 "The Garden of Eros", Palau de la Verreina, Barcelona
 "Group Show", Galerie Rodolphe Janssen, Brussels
 "Tendance", Abbaye Saint-André Centre d'Art Contemporain, Meymac, France
 "Word Enough to Save a Life, Word Enough to Take a Life", Clare College Mission Church,
London
 "Mayday", Centre d'Art Neuchâtel (CAN), Neuenburg, Switzerland
 "River Deep, Mountain High", Gallery Westland Place, London; University of Dundee, UK

1998 "Remix: Images photographiques", Musée des Beaux-Arts, Nantes
 "The Road", Beauvais, France
 "New Contemporaries", Tea Factory, Liverpool, et al.
 "Critical Distance", Andrew Mummery Gallery, London
 "Plastic Metropolis and Inventories", Shoreditch Biennale, London
 "Host", Tramway, Glasgow

1997 "Little Boxes", Cambridge Darkroom Gallery
 "On the Bright Side of Life: Zeitgenössische britische Fotografie", Neue Gesellschaft für
 Bildende Kunst Berlin, et al.
 "Public Relations: New British Photography", Stadthaus Ulm, Germany

1996 "Silent/Still", London Calling @ Arch 53, London
 "Spatial Penetration" (artists' collaboration), Galatasaray, Berlin
 "Stadtluft", Architektenkammer, Berlin
 "Flag", Clink Street Wharf, London
 "Euthanasia", Plummet, London

1995 "Stream", Plummet, London

Bibliography

2001 Glover, Izi, "Sophy Rickett", *Frieze*, July 2001
 Tufnell, Rob, "Sophy Rickett, Yellow Tree", *Portfolio*, June 2001
 "Sophy Rickett, Review", *The Independent on Sunday*, 1 April 2001
 The Fantastic Recurrence of Certain Situations: Recent British Art and Photography,
 exh. cat. Sala de
 Exposiciones del Canal de Isabel II, Madrid 2001
 Nothing, exh. cat. Northern Gallery for Contemporary Art, Sunderland, UK, 2001

2000 Townsend, Chris, "Sophy Rickett", *Hotshoe International*, March/April 2000

1999 Thrift, Julia, "Sophy Rickett", *Time Out*, 15 December 1999
 Ratnam, Niru, "Talent Front", *Scene*, December 1999
 Beech, Dave, "Review" *Art Monthly*, December 1999
 Shave, Stuart, "i-Dc: Night Vision", *i-D*, December 1999
 "Photography", *Zoo*, October 1999
 "Near and Elsewhere-Review", *Circa*, no. 89, Autumn 1999
 Corliss, Kieron, "Review", *Pill*, no. 4, July/August 1999

Common People: Arte Inglese tra Fenomeno e Realtà, exh. cat. Palazzo Re Rebaudengo, Guarene d'Alba, Italy, 1999
Jardin de Eros, exh. cat. Institut de Cultura de Barcelona 1999

1998	"New Contemporaries – Review", *The Times*, 18 July 1998
	Herbert, Martin, "Critical Distance", *Time Out*, 8 July 1998
	"New Contemporaries – Review", *The Guardian*, 7 July 1998
	Morrissey, Simon, "Amnesia", *Contemporary Visual Arts*, April 1998
	New Contemporaries, exh. cat. Tea Factory, Liverpool, et al. 1998
	Remix: Images photographiques, exh. cat. Musée des Beaux-Arts, Nantes 1998

1997	Currah, Mark, "Flag", *Time Out*, 29 May 1997
	Browning, Simon (ed.), *Surface: Contemporary Photographic Practice*, London 1997
	On the Bright Side of Life: Zeitgenössische britische Fotografie, exh. cat. Neue Gesellschaft für Bildende Kunst, Berlin, et al. 1997
	Public Relations. New British Photography, exh. cat. Stadthaus Ulm, Germany, 1997

1996	Van Mourik Broekman, Pauline, "Contemporary Flaneuses", *Mute*, Winter 1997
	Williams, Val, "Stream", *Creative Camera*, February 1997
	"No Young Brits at Flag", *Flash Art*, no. 188, vol. 29, 1997

| 1995 | Guha, Tania, "Stream", *Time Out*, 18 December 1995 |

Awards

2000	Fellowship at DCA – Dundee Contemporary Arts, Dundee, UK
	Artist in Residence, Grizedale Sculpture Park, Grizedale, UK
	The Woo Charitable Foundation Prize

Collections

BMW Financial Services Group Great Britain Collection, Hampshire, UK
Fondazione Sandretto Re Rebaudengo, Turin
Musée des Beaux-Arts, Nantes
Goldman Sachs, London
Merril Lynch, London
Texas Pacific Group Collection
Victoria and Albert Museum, London

DAVID SHRIGLEY

Born in Macclesfield, UK, 1968.
Currently lives and works in Glasgow.

Education

1988–1991 Glasgow School of Art, B. A. Fine Art

Solo Exhibitions

2001 Stephen Friedman Gallery, London
 Bard College, New York

2000 Galleri Nicolai Wallner, Copenhagen

1999 Stephen Friedman Gallery, London
 Yvon Lambert, Paris

1998 Galleri Nicolai Wallner, Copenhagen
 Yvon Lambert, Paris
 Bloom Gallery, Amsterdam

1997 Centre for Contemporary Art, Glasgow
 Stephen Friedman Gallery, London
 Hermetic Gallery, Milwaukee, USA
 Francesca Fiar, Bern, Switzerland
 Galleri Nicolai Wallner, Copenhagen
 The Photographers' Gallery, London

1996 Catalyst Arts, Belfast
 "The Contents of the Gap", Luxus Cont. e. V, Glasgow

1995 "Map of the Sewer", Transmission Gallery, Glasgow

Group Exhibitions

2001 "Open Country. Contemporary Scottish Artists", Le Musée cantonal des Beaux-Arts
 de Lausanne
 "The Fantastic Recurrence of Certain Situations: Recent British Art and Photography",
 Consejéria de Cultura, Madrid

2000 "The British Art Show 5", National Touring Exhibition, organized by the Hayward Gallery,
 London, for the Arts Council of England; Edinburgh et al.
 "One in the Other", London (with Ewan Gibbs)
 "Personal History", The Fruitmarket Gallery, Edinburgh
 "Diary", Cornerhouse, Manchester, et al.

1999 "Information, Kommunikation und Didaktik in der zeitgenössischen bildenden Kunst",
 Grazer Kunstverein, Graz, Austria
 "Getting the Corners", Or Gallery, Vancouver, Canada
 "Shopping, London", Exedra, Hilversum, The Netherlands
 "Plug In", Salon 3, London
 "Word Enough to Save a Life Word Enough to Take a Life", Clare College Mission Church,
 London
 "Common People – British Art between Phenomeon and Reality", Palazzo Re
 Rebaudengo, Guarene d'Alba, Italy
 "Waste Management", Art Gallery of Ontario
 "Free Coke", Greene Naftali Gallery, New York
 "Ainsi de suite 3 (deuxième partie)", Sétè, France

1998 "Surfacing – Contemporary Drawing", Institute of Contemporary Arts, London
 "Matthew Benedict, Yves Chaudouét, Anne-Marie Schneider, David Shrigley,
 and Alexander Eonin", New York
 "Real Life", Galleria S.A.L.E.S., Rome
 "Young Scene", Wiener Secession, Vienna
 "Habitat", Centre for Contemporary Photography, Melbourne

1997 "Blueprint, de Appel Foundation", Amsterdam
 "Tales of The City", Stills Gallery, Edinburgh
 "Public Relations New British Photography", Stadthaus Ulm, Germany
 "Caldas Biennale", Caldas da Rainha, Portugal
 "About Life in the Periphery", Wacker Kunst, Darmstadt, Germany
 "Appetizer, Free Parking", Toronto
 "Slight", Norwich Gallery, Norwich, UK
 "Biscuit Barrel", Margaret Harvey Gallery, St. Albans, UK

1996 "Sarah Staton Superstore", Up & Co, New York
 "Absolute Blue and White", Inverleith House, Edinburgh
 "The Unbelievable Truth", Stedelijk Museum Bureau Amsterdam; Tramway, Glasgow
 "Fucking Biscuits and Other Drawings", Bloom Gallery, Amsterdam
 "Big Girl/Little Girl", Collective Gallery, Edinburgh
 "White Hysteria", Contemporary Art Centre of South Australia, Adelaide, Australia
 "Toons", Gallerie Campbells Occasionally, Copenhagen
 "Upset", James Colman Fine Art, London

1995 "Scottish Autumn", Bartok 23 Galeria, Budapest

1994 "Some of My Friends", Gallerie Campbells Occasionally, Copenhagen
 "New Art in Scotland", Centre for Contemporary Art, Glasgow

1992 "In Here", Transmission Gallery, Glasgow

Publications

2000 Collaboration with Yoshitomo Nara in *Bijutsu Techo, 2000*

1999 Weekly cartoon in the *Independent on Sunday*

1998 *Blank Page and Other Pages*, ed. The Modern Institute, Glasgow 1998
 To Make Meringue You Must Beat the Egg Whites Until They Look Like This, ed. Galleri
 Nicolai Wallner, Copenhagen 1998
 Why we Got the Sack from the Museum, The Redstone Press, London 1998

1996 *Drawings Done Whilst On Phone to Idiot*, The Armpit Press, Glasgow 1996
 Err, Book Works, London 1996
 Let Not These Shadows Fall Upon Thee, ed. Tramway, Glasgow 1996

1995 *Enquire Within*, The Armpit Press, Glasgow 1995

1994 *Blanket of Filth*, The Armpit Press, Glasgow 1994

1992 *Merry Eczema*, Black Rose, Glasgow 1993

1991 *Slug Trails,* Black Rose, Glasgow 1991

Bibliography

2000 Jones, Jonathan, "Beck's Futures", *The Guardian*, 21 March 2000

1999 Coomer, Martin, Review, *Time Out*, 31 March – 7 April 1999, p. 45
 Searle, Adrian, "Objects of Ridicule", *The Guardian*, 23 March 1999, p. 9

1998 Bracewell, Michael, "Renaissance Man", *The Guardian*, December 1998
 Palmer, Judith, "The Wonderful World of Shrigley", *The Independent*, November 1998
 "Insert: David Shrigley", *Parkett*, no. 53, August 1998, pp. 153–168
 Killam, Brad, "David Shrigley", *New Art Examiner*, no. 4, December 1997/January 1998, p. 59

1997 Beech, David, "David Shrigley: The Photographers' Gallery", *Art Monthly*, no. 204,
 March 1997, pp. 29–30
 Thrift, Julia, "David Shrigley, Roman Signer", *Time Out*, 26 February 1997

1996 Larsen, Lars Bang, "Toons: Campbells Occasionally, Copenhagen", *Flash Art*,
 November/December 1996
 Wilson, Mike, "David Shrigley: Catalyst Arts, Belfast", *Circa*, Winter 1996
 Findlay, Judith, "David Shrigley: Artist", *Flash Art*, May/June 1996, p. 64
 Findlay, Judith, "David Shrigley: Transmission", *Flash Art*, January/February 1996, p. 106

1995 Bracewell, Michael, "Jesus Doesn't Want Me for a Sunbeam", *Frieze*, no. 25,
 November/December 1995, pp. 50–51
 Findlay, Judith, "David Shrigley: Map of the Sewer – Transmission Gallery", *Zing Magazine*,
 Winter 1995

Collections

BMW Financial Services Group Great Britain Collection. Hampshire, UK
Victoria and Albert Museum, London

BRIDGET SMITH

Born in Leigh-on-Sea, UK, 1966.
Currently lives and works in London.

Education

1984–1985 Central School of Art and Design, London
1985–1988 Goldsmiths College, London, B. A. (Honors)
1993–1995 Goldsmiths College, London, M. A. Fine Art

Solo Exhibitions

2001 Gallery Side 2, Tokyo

2000 Frith Street Gallery, London
 Galerie Barbara Thumm, Berlin

1999 British Council Window Gallery, Prague
 Fotogalleriet, Oslo

1998 Galerie Barbara Thumm, Berlin

1997 Frith Street Gallery, London

1996 "All or Nothing", Studio Gallery, Budapest

1995 Entwistle Gallery, London

Group Exhibitions

2001 Arco Artfair, Madrid
 "ExtraOrdinary: American Places in Recent Photography", Madison Art Center, Madison,
USA

2001 "Konfrontace: Czech and British Artists in the UK", Czech Centre, London
 "Because a Fire Was in My Head", South London Gallery, London
 "Real Places?", Westfälischer Kunstverein, Münster, Germany
 "Give and Take", Jerwood Space, London

1999 "Vertigo: The Future of the City", The Old Fruitmarket, Glasgow
 "0 to 60 in 10 Years", Frith Street Gallery, London
 "Blue Suburban Skies", The Photographers' Gallery, London
 "Natural Dependency", Jerwood Space, London

1998 "History Mag Collection", Ferens Art Gallery, Hull, UK
 "Inbreeder: Some English Aristocracies", Collective Gallery, Edinburgh
 "Your Place or Mine", Elga Wimmer Gallery, New York
 "New British Photography", Real Gallery, New York
 "Made in London (Simmons & Simmons Collection)", Museu de Electricidade, Lisbon
 "Group Show", Frith Street Gallery, London
 "The Tarantino Syndrome", Künstlerhaus Bethanien, Berlin

1997 "Backpacker", Chiang Mai, Thailand
 "The Oscars", La Nuova Pesa, Rome
 "Public Relations: New British Photography", Stadthaus Ulm, Germany
 "Within These Walls", Kettles Yard, Cambridge
 "History. Works from the MAG Collection", Ferens Art Gallery, Hull, UK, et al.
 "Whisper & Streak", Galerie Barbara Thumm, Berlin
 "World of Interiors", Binz 39, Zurich
 "Alpenblick: Die zeitgenössische Kunst und das Alpine", Kunsthalle Wien, Vienna

1996 "Try", Royal College of Art, London
 "Ace", Hayward Gallery, London

1995 "MA Exhibition", Goldsmiths College, London
 "The British Art Show 4", National Touring Exhibition, organized by the Hayward Gallery,
 London, for the Arts Council of England; Edinburgh et al.
 "Dorothy Cross Ceal Floyer, Cornelia Parker, Helen Robertson, Bridget Smith",
 Frith Street Gallery, London

1994 "!GOL!", Mark Boote Gallery, New York
 "The Event", 152c Brick Lane, London
 "Close Encounters', Ikon Gallery, Birmingham
 "Institute of Cultural Anxiety: Works from the Collection", Institute of Contemporary Arts,
 London
 Räume für neue Kunst – Rolf Hengesbach, Wuppertal, Germany
 "Having It", Spital Studio, London

1993	"Wonderful Life", Lisson Gallery, London
	"Time Out Billboard Project", London
	"Tony Hayward, Jaki Irvine, Ian Pratt, Bridget Smith", Riverside, London
1992	"Hit and Run", London
	"Love at First Sight", Showroom Gallery, London
1991	"Rachel Evans, Anya Gallaccio, Bridget Smith", Clove Gallery, London
1990	"Third Eye Centre", Centre for Contemporary Art, Glasgow
1989	West Norwood Railway Arches, London
	"Current", Swansea Arts Centre, Swansea, UK
1986	"New Contemporaries", Institute of Contemporary Arts, London, et al.

Bibliography

2001	"Tokyo Inside Out – Bridget Smith", *Tate Magazine*, Spring 2001, pp. 34–37
2000	"Vox Pop", *Make Magazine*, no. 90, December 2000 – February 2001, p. 17
	Ward, Ossian, "Bic Parker's Vegas", *Limb by Limb*, October/November 2000, p. 13
	Montgomery, Robert, "Bridget Smith", *Flash Art*, no. 212, vol. 33, May/June 2000, p. 118
	Thrift, Julia, "Bridget Smith – Frith Street", *Time Out*, 23 February – 1 March 2000
	Buck, Louisa, "Our Choice of London Galleries", *The Art Newspaper*, February 2000
	Hill, Albert, "Pretty Vacant", *Blueprint*, no. 169, February 2000
	Hickey, Dave, "Double or Quits", *Frieze*, no. 50, February 2000, p. 62
	Ward, Ossian, "The Porn Shot", *Limb by Limb*, January/February 2000, pp. 42–43
1999	Cisar, Karel, "Stardust", *Umelec*, October 1999
1998	Schreiber, Susanne, "Eine spannende Ausgrabung und zwei Wiederbegegnungen", *Handelsblatt*, no. 110, 12 June 1998
	Mahoney, Martin, "Your Place or Mine", *Time Out New York*, 21–28 May 1998, p. 59
	"Inbreeder: Some English Aristocracies", *Art Monthly*, no. 217, 1998, p. 37
	The Campaign Against Living Miserably, exh. cat. Royal College of Art Galleries, London 1998
1997	"Kurzkritik – Drei Künstler aus London in der Binz", *Neue Zürcher Zeitung*, 11 November 1997
	"Zürich – Janette Parris, Andreas Rüthi und Bridget Smith in der Stiftung Binz", *Kunstbulletin,* no. 11, November 1997
	"Hollow Illusions. The Work of Bridget Smith", *Portfolio*, no. 26, Autumn 1997, pp. 46–47
	"Within these Walls", *Blueprint,* September 1997, p. 48
	Tozer, John, Review of Kettles Yard exhibition, Cambridge, *Art Monthly*, September 1997, pp. 32–34
	Cruz, Juan, Review of Frith Street Gallery exhibition, London, *Art Monthly*, June 1997, pp. 30–32
	Alpenblick: Die zeitgenössische Kunst und das Alpine, exh. cat. Kunsthalle Wien, Vienna 1997
	Simon Browning (ed.), *Surface: Contemporary Photographic Practice*, London 1997
	Only the Lonely, exh. cat. Frith Street Gallery, London 1997
	Public Relations: New British Photography, exh. cat. Stadthaus Ulm, Germany, 1997
	Within These Walls, exh. cat. Kettles Yard, Cambridge 1997
1996	Cheddie, Janice, "I do, I don't", *Women's Art Magazine*, January/February 1996
1995	Maloney, Martin, "Glitz and Thrift", *Blueprint*, December 1995
	Maloney, Martin, "Ouverture", *Flash Art*, no. 183, Summer 1995
	Hunt, Ian, "Entwistle", *Frieze*, May 1995, pp. 59–60
	Worsdale, Godfrey, "Entwistle", *Art Monthly*, April 1995
1994	Lillington, David, "The Event", *Time Out*, 13–20 July 1994
	Durden, Mark, "Close Encounters, Ikon Gallery", *Creative Camera*, December 1993/January 1994
	British Art Show 4, exh. cat. National Touring Exhibition, Edinburgh et al., London 1994
1993	Cottingham, Laura, "Wonderful Life", *Frieze*, September/October 1993
	Guha, Tania, "Riverside", *Time Out*, 29 December 1992 – 5 January 1993

Awards

2000 Tate Tokyo Residency

1991 Women's Photography Award, GLA (London Arts Board)

1986 David Murray Studentship Award

Collections

BMW Financial Services Group Great Britain Collection. Hampshire, UK
Victoria and Albert Museum, London

HANNAH STARKEY

Born in Belfast, 1971.
Currently lives and works in London.

Education

1992–1995 Napier University, Edinburgh, B. A. (Honors) Photography and Film
1996–1997 Royal College of Art, London, M. A. Photography

Solo Exhibitions

2000 Irish Museum of Modern Art, Dublin
Maureen Paley/Interim Art, London
"Progetto", Castello di Rivoli – Museo d'Arte Contemporanea, Rivoli–Turin

1999 Nederlands Foto Instituut, Rotterdam
Cornerhouse, Manchester
Galleria Raucci/Santamaria, Naples

1998 Maureen Paley/Interim Art, London

1995 "Hannah Starkey – Scottish Homes", Stills Gallery, Edinburgh

Group Exhibitions

2001 "Extended Painting", Monica de Cardenas, Milan
"Instant City", Museo Pecci, Prato, Italy
"Citibank Private Bank Photography Prize", The Photographers' Gallery, London

2000 "Suspendidos", Centro de Fotografía, Universidad de Salamanca
"Imago", Universidad de Salamanca
"Give and Take: The Contemporary Art Society at the Jerwood", Jerwood Space, London

1999 Galerie Rodolphe Janssen, Brussels
"Clues, Monte Video", Netherlands Media Art Institute, Amsterdam
"3rd International Tokyo Photo Biennial", Tokyo Metropolitan Museum of Photography

1998 "Silver & Syrup: A Selection from the History of Photography", Victoria and Albert
Museum, London
"Remix: Images photographiques", Musée des Beaux-Arts, Nantes
"Look at me", The British Council Touring Exhibition, Kunsthal Rotterdam et al.
"Real Life", Galleria S.A.L.E.S., Rome
"Sightings – New Photographic Art", Institute of Contemporary Arts, London
"Shine – Photo '98", National Museum of Photography, Film & Television,
Bradford, UK
"Modern Narratives: The Domestic and the Social", Artsway, London

1997 "John Kobal Foundation", National Portrait Gallery, London

Bibliography

2001 Charlesworth, J. J., "Reality Check", *Art Monthly*, no. 247, June 2001
Howarth, Sophie, "A Life Less Ordinary", *Tate*, no. 24, Spring 2001

2000 Rawsthorn, Alice, "Field of Vision", *Harper's Bazaar*, December 2000
"200 for 2000, Maureen Paley Nominates", *i-D*, no. 200, August 2000
Coomer, Martin, "Give & Take", *Time Out*, no. 1560, 12–19 July 2000
"Hannah Starkey", *Habitat Artclub*, Summer 2000
Von Planta, Regina, "Hannah Starkey bei Interim Art", *Kunst-Bulletin*, no. 5, May 2000
"Artnotes", *Art Monthly*, no. 234, March 2000
"2000 Millennium Arts Special", *The Independent Magazine*, 1 January 2000
Maconochie, Tiggy, "Do We Like Art?" *Fashion – Images de Mode*, no. 4, 2000
A Project for the Castle. Hannah Starkey, exh. cat. Castello di Rivoli – Museo d'Arte
Contemporanea, Rivoli–Turin

1999 Ruyters, Domeniek, "Onwaarachtige snapshots – Hoe Sharon Lockhart en Hannah
Starkey een brug slaan tussen de jaren tachtig en negentig", *Metropolis M*, no. 5,
October/November 1999
Davis, Maggie, "Everyday People", *Vogue*, August 1999
Bishop, Claire, "Hannah Starkey – Quietly Loaded Moments", *Flash Art*, no. 207, vol. 32,
Summer 1999
"News: Amsterdam/Clues", *Flash Art*, no. 206, vol. 32, May/June 1999
Townsend, Chris, "Dreaming of Me", *Hotshoe International*, May/June 1999
"Hannah Starkey, Solitudini sospense per la moda di Vogue", *Photo*, no. 26, May 1999
D., A., "Hannah Starkey. La vita è un film. Tra sogno e realtà", *Arte*, no. 308, April 1999
"Readings", *Harper's Magazine*, April 1999

"Rivelazioni a Napoli", *Photo*, no. 24, March 1999
Del Vecchio, Gigiotto, "Hannah Starkey", *Segno*, no. 167, February/March 1999
Jones, Jonathan, "Five Artists to Invest in", *Life*, 7 February 1999

1998 Coomer, Martin, "Hannah Starkey", *Time Out*, 18–25 November 1998
 Tebbs, Paul, "Amongst Women", *Source*, no. 18, Winter 1998
 Schwabsky, Barry, "Openings. Hannah Starkey", *Artforum*, September 1998
 Durden, Mark, "Sightings: New Photographic Art", *Art Monthly*, no. 214, March 1998

Awards

2000 The Arts Foundation 10th Anniversary Award

1999 Award for Excellence, 3rd International Tokyo Photo Biennial, Tokyo

1997 The Photographers' Gallery Award
 Vogue Conde Nast Award
 The Sunday Times Award
 Deloitte and Touche Fine Art Award
 John Koba Portrait Award

1995 National Housing Body for Scotland

Collections

BMW Financial Services Group Great Britain Collection. Hampshire, UK
Victoria and Albert Museum, London

Editor
Jone Elissa Scherf, George St. Andrews

Editing
Jone Elissa Scherf, George St. Andrews

Translation
Bettina Mundt

Copy editing
Christine Traber
Fiona Elliott

Graphic design
Andreas Platzgummer

Reproduction
Franz Kaufmann GmbH, Stuttgart

Printed by
Dr. Cantz'sche Druckerei, Ostfildern-Ruit

© 2001 Editor, Hatje Cantz Verlag, Ostfildern-Ruit,
artists and author

Published by
Hatje Cantz Verlag
Senefelderstraße 12
73760 Ostfildern-Ruit
Germany
Tel. +49/7 11/4 40 50
Fax +49/7 11/4 40 52 20
Internet: www.hatjecantz.de

DISTRIBUTION IN THE US
D.A.P., Distributed Art Publishers, Inc.
155 Avenue of the Americas, Second Floor
New York, N.Y. 10013-1507
USA
Tel. +1/2 12/6 27 19 99
Fax +1/2 12/6 27 94 84

ISBN 3-7757-1119-8

Printed in Germany

Die Deutsche Bibliothek – CIP Cataloguing-in-Publication-
Data
A catalogue record for this publication is available from
Die Deutsche Bibliothek

Photographic credits

Tom Hunter, p. 11, by courtesy of Jay Joplin, London
Sarah Jones, p. 6, by courtesy of Maureen Paley Interim
Art, London
Sophy Rickett, p. 8, by courtesy of Emily Tsingou Gallery,
London
David Shrigley, p. 13, by courtesy of Stephen Friedman
Gallery, London
Bridget Smith, p. 10, by courtesy of Frith Street Gallery,
London
Hannah Starkey, p. 9, by courtesy of Maureen Paley Interim
Art, London

Illustrations on pp.14–59:
BMW Financial Services Group GB Collection, Hampshire,
UK

BMW Financial Services Group
Great Britain

Acknowledgment

The editors would like to thank BMW Financial Services
Group Great Britain, Petra Kerp, the curator Mark Haworth-
Booth, and the many people and organizations who have
contributed to "Making Your Dreams Come True".

Endpapers
Hannah Starkey, *Horsepower 1*, 1999 (Detail)
Hannah Starkey, *Horsepower 4*, 1999 (Detail)